Hazel Soan's
Watercolour
Rainbow

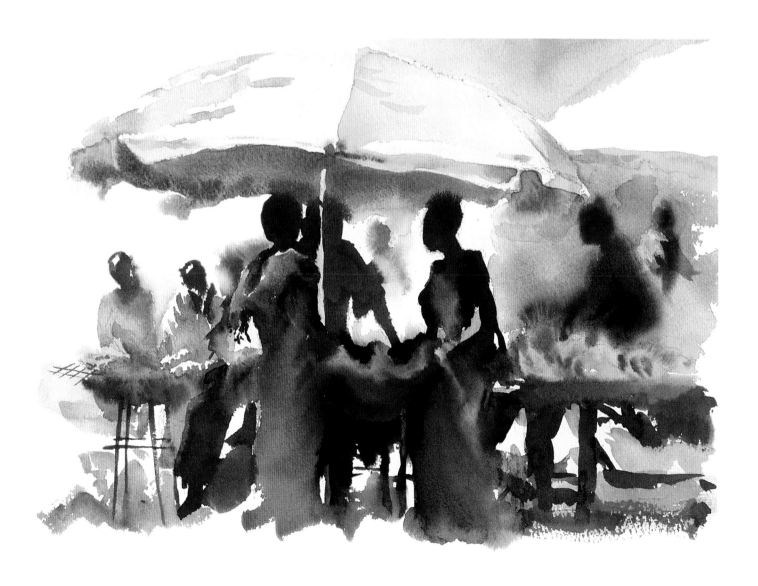

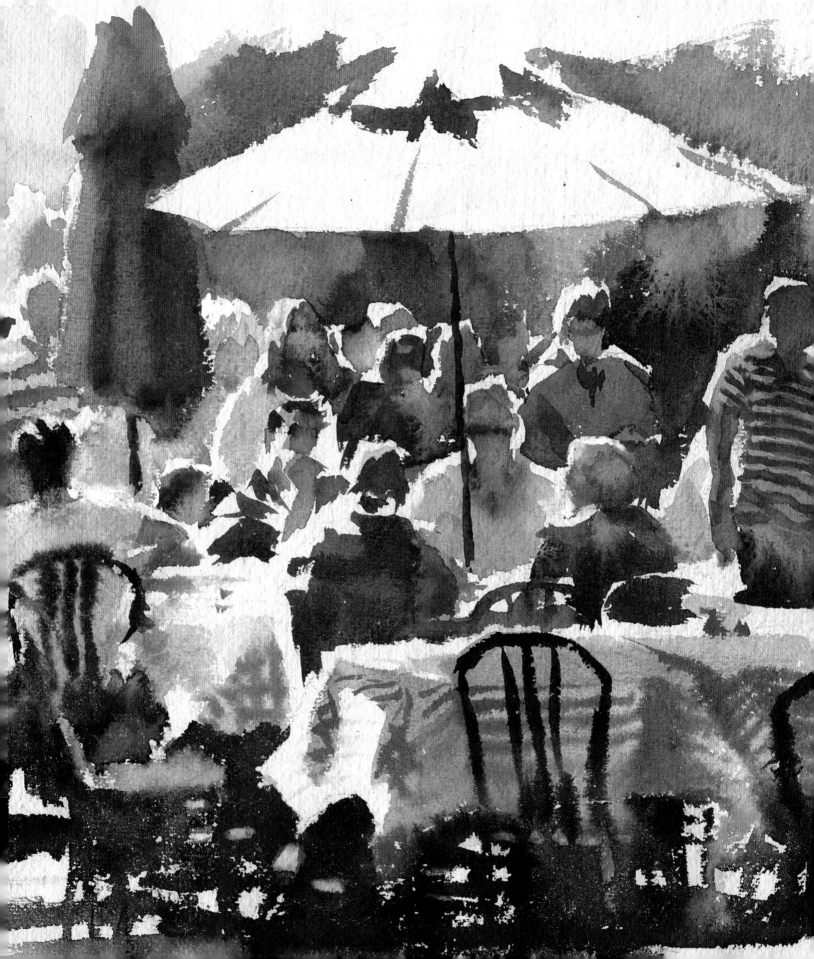

Hazel Soan's Watercolour Rainbow

Exploring the colours in your palette

BATSFORD

Dedication

To the God of Light and
in memory of our beloved dog Yassen.

Acknowledgements

A big thank you to Cathy Gosling for believing in
the idea and making it happen. To my sister Rosie
for reading the first draft. To Lucy Smith, my editor,
who has been delightful to work with and to Zoë
Anspach for the marvellous design: they both
made the book look just as I hoped. To Diana
Vowles for great text editing. To Madeleine
Stone for photography. To Jennie Ryland for her
encouragement. And to my husband and son
who keep me ever on my toes.

Page 1: **Market Day**
30.5 x 40.5cm (12 x 16in)

Page 2: **Boardwalk Café, San Francisco**
30.5 x 33cm (12 x 13in)

Right: **The Wishing Well**
25.5 x 30.5cm (10 x 12in)

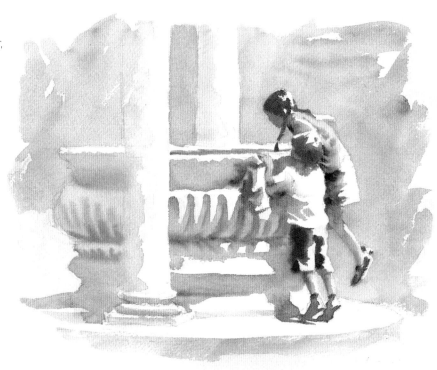

First published in the United Kingdom in 2014 by
Batsford
10 Southcombe Street
London W14 0RA

An imprint of Anova Books Company Ltd

Copyright © Batsford 2014
Text and illustrations © Hazel Soan 2014

The moral rights of the author have been asserted.

ISBN-13: 9781849941242

A CIP catalogue record for this book is available from the British Library.

20 19 18 17 16 15 14
10 9 8 7 6 5 4 3 2 1

Reproduction by Rival Colour Ltd, UK
Printed by 1010 Printing International Ltd, China

This book can be ordered direct from the publisher at the website:
www.anovabooks.com, or try your local bookshop.

Contents

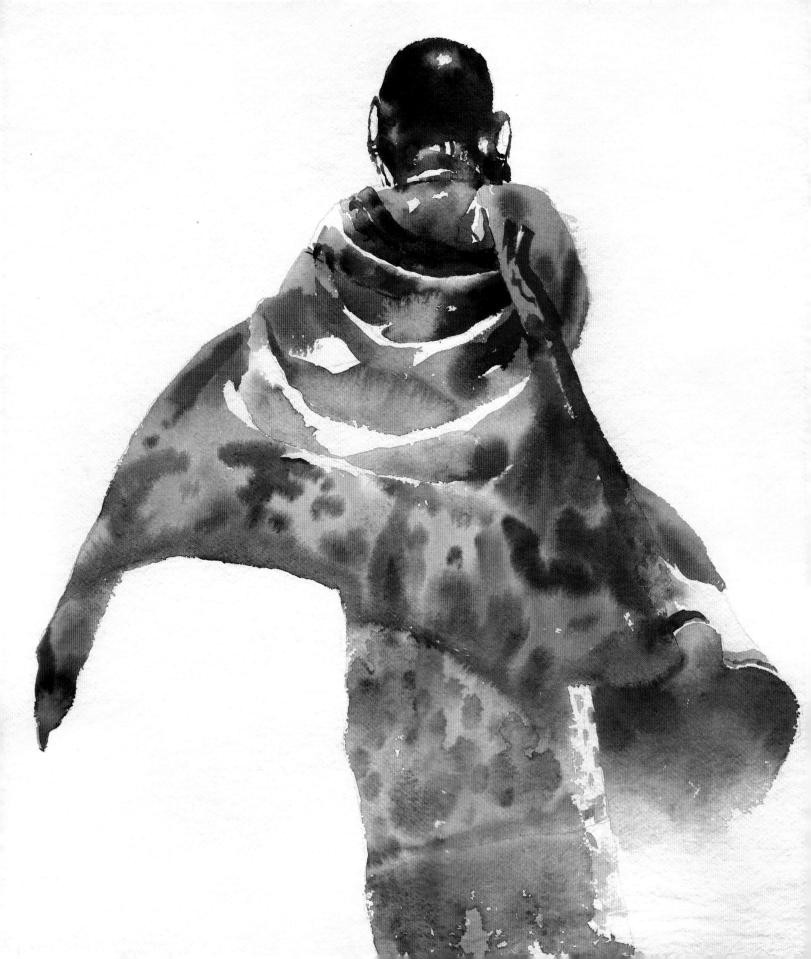

Introduction: The Rainbow in Your Palette

Colour is one of the chief attractions in a painting, both for the artist and the viewer, and the glorious pigments, transparent washes and vibrant hues of watercolour make it a particularly alluring medium. A vast array of colours and tones can be explored simply by adding water to pigment, producing paintings of breathtaking clarity and unique character.

This adds greatly to the thrill of painting, but there are times when the promise of radiant colour leads instead to disappointment. By unlocking the treasures of the palette, this book aims to broaden your knowledge so that you can approach choosing and mixing colour with confidence. Once you understand the way watercolour works and the individual characteristics of the rainbow of colours you will be equipped to show them at their captivating best.

Owning Nothing but the Wind
56 x 53.5cm (22 x 21in)

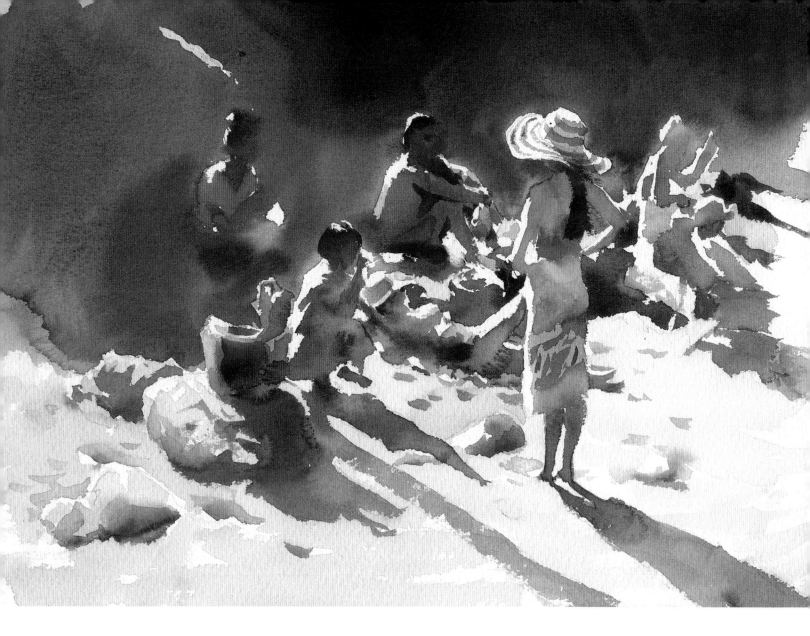

San Diego Brunch

28 x 38cm (11 x 15in)

In this family beach scene, just three colours, Indian Yellow, Permanent Rose and Ultramarine (Green Shade), are mixed to make the reds, pinks, violets, blues and greens of the beachwear. A dash of Light Red is added into the flesh tones to give them more body.

Too Much of a Good Thing

In watercolour painting, everything depends on freshness. The white paper provides the light for luminous and transparent glazes of colour, and all you need to do is choose your paints, mix them and brush them into place.

That sounds simple, but how do you know which colours to choose? Most aspiring artists follow a list from an art book or buy a ready-made palette, but a collection of tubes and pans of lovely colours do not always translate into radiant watercolour paintings. In fact, watercolours are actually made more colourful by limiting the number of pigments, and it is how they are used in combination that is more relevant to the painter than individual hues. Although I carry as many as 22 different colours in my palette I use only 12-16 on a regular basis, rarely more than six in any one painting and often only three.

How to Use this Book

In order to ensure that this book has practical application, it is limited to the colours included in the paintings. The first four chapters discuss the use of colour in painting, present an overview of watercolour pigments and explain how to mix and lay them to optimum effect. Thereafter the chapters are divided by hue and offer specific information on individual colours. Watercolour ranges offer plenty more than are discussed here, all wonderful, but trying to include them all would have made for a very large and potentially confusing book. However, I hope that after you have read *Watercolour Rainbow* you will try other colours too, matching their properties to the categories identified in this book - warm and cool versions, transparent and opaque pigments - and find the set that works best for you.

I use predominantly Winsor & Newton Artists' Water Colour, so the names of the colours here are those used by that brand. Although many manufacturers offer similar names, the hue and consistency may vary. The main thing is to find a manufacturer whose colours you enjoy and get to know a few colours really well so that you can create tints and blends intuitively. All manufacturers have an artists' quality range and a cheaper range; the former will give you better results and, in the long run, is more economical as the paints contain less binder and more pigment. The intense colours go further, flow better and are more luminous.

The names of colours are often long, but most of them help to explain the characteristics of the colour. Becoming familiar with them will enable you to maximize their effect on paper. The watercolour medium is perfect; all you have to do is allow it to show its true colours, literally.

In reproduction, the subtlety of watercolour is sometimes lost by the limitations of the printing process. Please bear this constraint in mind as you go through the book, especially in relation to the single coloured swatches representing actual pigment colours.

Soft Summer Circles
38 x 56cm (22 x 15in)
Although the range of colours in this bouquet is reproduced by the printing process, the pigments used - Permanent Rose, Winsor Violet, Ultramarine, Aureolin, Quinachridone Gold and a dash of Cadmium Red - can still be recognized.

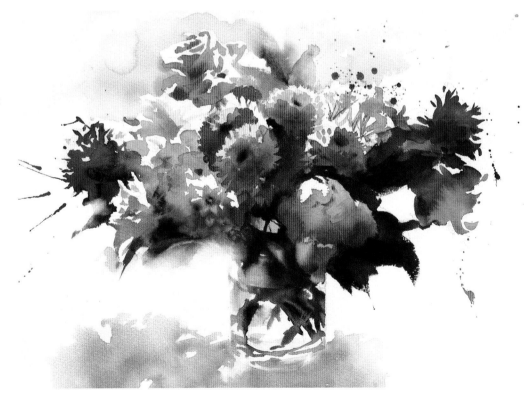

1. Colour Rules

A knowledge of colour theory will really help you to use colour effectively. There are rules that colours abide by and this will enable you to mix your pigments using informed choice rather than just relying on guesswork. Realizing how the eye perceives colour will also liberate your painting. Colour constancy (the tendency to see a red as red or a yellow as yellow, whatever the light conditions) is programmed into the brain, so we can identify a colour even in shadow - yet the artist must override this in order to see and paint the character of the colour that is actually present. Once you know the science behind perception, you will be able to perceive a yellow in shadow as brown or a white as blue rather than just following your first presumptions.

Primary Allegiance
35.5 x 28cm (14 x 11in)

The Supremacy of Tone

When the word 'colour' is used in painting, it encompasses both hue and tone. The hue is the feature of a colour that enables us to classify it, for example red, yellow or blue. The tone, or value, is the lightness or darkness of the colour as it is modified by light. Every colour has both a hue and a tone.

In figurative painting, gauging tone is more important than matching hue because the representation of light and shade (tone, or value) is the code by which we interpret the coloured patterns on the paper as being three-dimensional forms and spaces. In other words, it is the arrangement of light and dark values that describes whether something is rounded or angular, far or near, behind or in front.

In watercolour, the white paper represents the light, so the watercolourist largely paints shade; lit objects are tinted and highlights are left untouched. Being able to assess the tonal value of a colour is therefore vital in order to paint successfully.

Bike Menders
30.5 x 40.5cm (12 x 16in)
The reds are crucial to the success of this painting, but their impact lies in the use of their tone as much as in their strong hue.

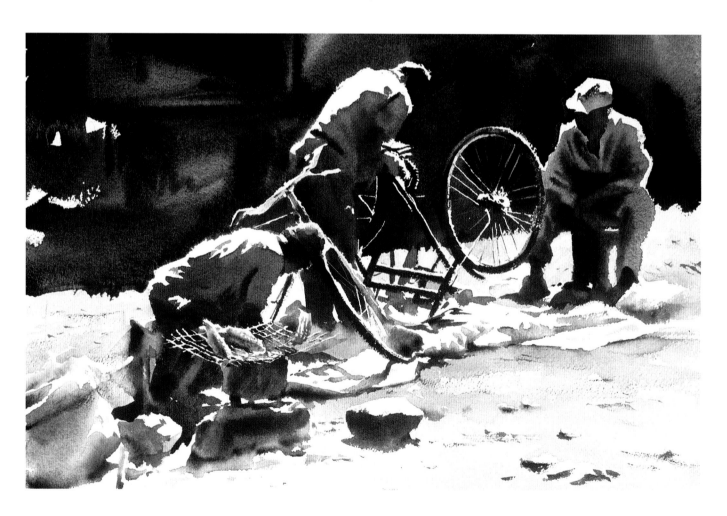

No Colour is Absolute

Most people assume that objects possess the colour they appear - for example that a tomato is red, or a lemon is yellow - but this is not how it works. In fact, the surfaces of objects absorb and reflect light to varying degrees and transmit that light in different wavelengths which are then perceived by the eye as colours. Objects do not own their colour - rather they demonstrate the colour of the light leaving their surface. If an object scatters all the wavelengths of light shining upon it, it will appear white, while if it absorbs all the wavelengths it will appear black. The different wavelengths transmitted in between these two extremes depend largely on the reflective and refractive properties of the surface and the ambient illumination.

Knowing how colour is perceived by the eye may not directly help you to become a better painter, but it will free you from the assumption that an object has a definitive colour. Once you get used to the idea that colour is not absolute, that the light or shade falling on an object alters the perceived or 'local' colour, you will concern yourself with relative tone and relative colour instead of matching hue.

QUINACRIDONE RED

INDANTHRENE BLUE

QUINACRIDONE GOLD

PRUSSIAN BLUE

INDIAN YELLOW

PERMANENT ROSE

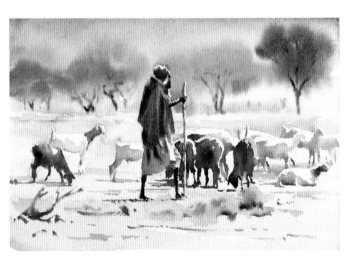

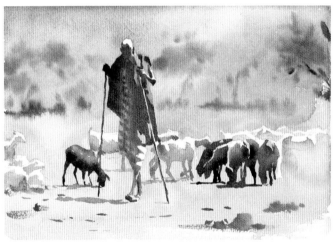

The colours in a painting are not chosen by trying to match the individual hues in the subject but rather by selecting a combination of pigments that will together approximate to its overall colouring. These two paintings look remarkably similar in colouring but the colours employed in the first (left) are Indanthrene Blue, Quinacridone Gold and Quinacridone Red, while in the second (right) they are Prussian Blue, Indian Yellow and Permanent Rose.

The Basics of Colour Mixing

The painter is concerned with the mixing of pigments. This is termed subtractive colour mixing and is based on making black, which is the sum of all colours of pigment mixed together (in light, all the colours of the spectrum mix together to make white, termed additive colour mixing).

Red, yellow and blue are primary colours; they cannot be mixed from other colours. When two primaries are mixed together, secondary colours result, making orange (red + yellow), green (blue + yellow) and violet (red + blue). The primary colour excluded from these pairs is called the opposite colour (opposite across a colour circle) or the complementary colour (completing the whole). When all three primaries, or a secondary and its opposite, are mixed together they make the tertiary colours – brown, grey, and finally black.

The colour wheel is a diagram that turns the spectrum of the rainbow – red, orange, yellow, green, blue, violet – into a circle to show the order of colours and visually demonstrates opposite colours and temperature bias.

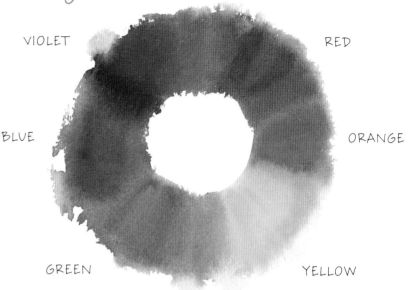

The Colour Wheel

With the spectrum of the rainbow turned into a circle, the complementary colours can be seen opposite each other and the warm and cool sectors are easily recognized. Blue is the opposite colour to orange, red to green and yellow to violet. Red, orange and yellow are warm colours, while green, blue and violet are cool.

Cadmium Red, Cadmium Yellow and Cobalt Blue

The manufactured colours closest to the three primary hues are Cadmium Red, Cadmium Yellow and Cobalt Blue. As the first two are opaque pigments and the last is slightly opaque, black cannot be reached by mixing them together because they are not dark enough in themselves.

Prussian Blue, Permanent Rose and Indian Yellow

The intensity needed to reach true black is found in transparent colours, so in practice the 'primary' colours are more similar to the three primaries of process printing: cyan, magenta and yellow. Here, the trio approximating those colours is Prussian Blue, Permanent Rose and Indian Yellow.

Indanthrene Blue, Quinacridone Gold and Quinacridone Red

Many transparent primary combinations mix to make black. This and the one left are the colour combinations used in the paintings on the previous page. You can see why the overall colouring looks similar: both combinations include all the colours of the rainbow but from a different set of primary hues.

Permanent Rose, Winsor Lemon and Winsor Blue

Each manufacturer provides information on the primaries that offer the widest range of hues possible with just three colours. In the Winsor & Newton Artists' Water Colour range they are Winsor Lemon, Winsor Blue (Red Shade) and Permanent Rose.

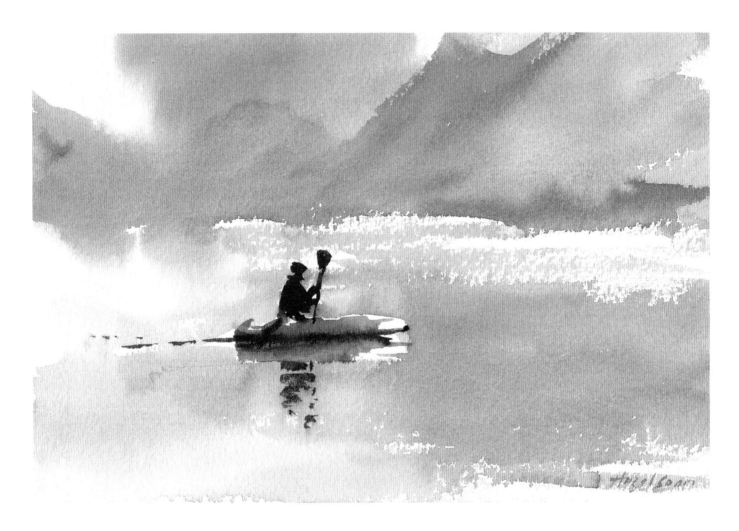

Freedom of the Wilderness
20 x 28cm (8 x 11in)
The contrast of two hues in opposition makes each more vibrant – the warmth of the Cadmium Red kayak turns the watery wash of Ultramarine (Green Shade) cooler and bluer, and the canoeist, mixed from both colours, appears blacker than the mix actually is.

Opposite Colours: Completing the Colour Circle

The eye (or more accurately the brain) is forever trying to balance and complete the colour circle – you can discover this by looking at a colour, closing your eyes and noting the afterimage of opposite colour on your eyelid. Compensating for a missing colour, the eye responds by seeing the neutrals – greys or browns – as leaning to that colour, thus shadows look more mauve or blue under a yellow-orange light. The artist takes full advantage of this compensatory phenomenon by setting colours against their opposites to make them appear more vibrant – the reason why a limited palette makes for a colourful painting.

Temperature Bias

An important element of colour is the bias towards red or blue that is termed temperature. The painter uses this to control atmosphere and mood and to suggest depth and space. Warm colours promote a cheerful atmosphere and advance to the front of a painting, while cool colours create calm, gentle and sombre moods and suggest recession. In general the reds, oranges and yellows are the warm colours and the blues, greens and violets are cool, but for the painter it is actually the undertone of a colour that makes it appear cooler or warmer and its temperature is classified in relation to other colours of the same hue - so a red can be described as cool and a blue as warm. Not surprisingly, colours that lean towards red are classified as warm colours, while those that veer towards blue or green (the opposite of red) are termed cool colours.

For example, Alizarin Crimson has an undertone of blue and is therefore a cool red. Ultramarine is a blue that heads back towards red, away from green, and so is classed as a warm blue, while Prussian Blue, moving away from red towards green, is termed a cool blue.

The awareness of temperature bias aids greatly in choosing colour combinations and mixing colours. Knowing which way a colour leans tells you whether it is suitable for a particular colour choice and what is needed in a mix.

San Giorgio Dawn, Twice
12.5 x 23cm (5 x 9in)
In these two Venetian watercolours, painted about an hour apart, the difference in colour temperature between red and blue is conspicuous. Before the dawn, the sky is ablaze with warm reds, while after the sun rises, the cooler blues and yellows create another mood altogether.

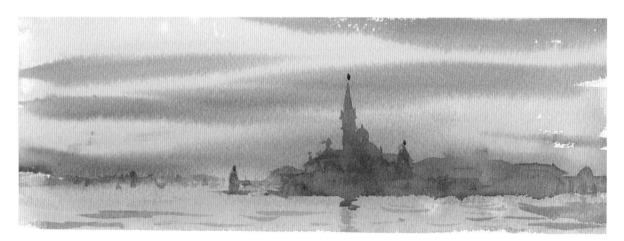

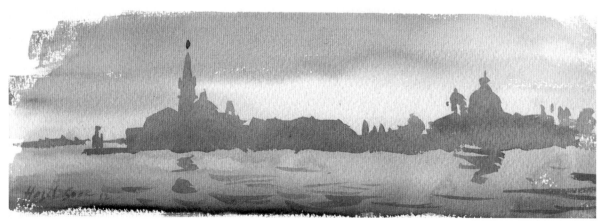

Sleeping on Sand

30.5 x 35.5cm (12 x 14in)

The two paintings on this page demonstrate the potential of temperature bias offered by blues. In the painting of the sleeping lioness, the cool of Prussian Blue suffuses the whole image, its 'greenness' muting the warmth of Yellow Ochre, Burnt Sienna and Sepia.

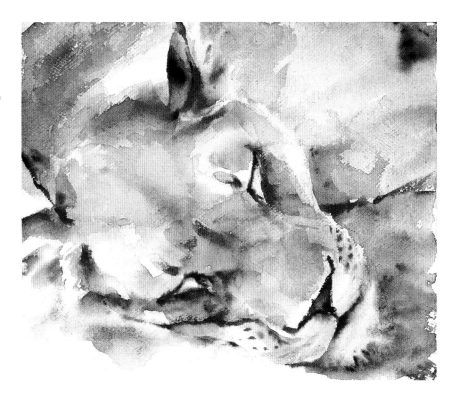

Nobody Loves Me

30.5 x 30.5cm (12 x 12in)

The warmth of Ultramarine (Green Shade) serves the opposite purpose in this painting of a hyena, heating the Yellow Ochre, Burnt Sienna, Winsor Violet and Sepia to a noticeably warmer disposition.

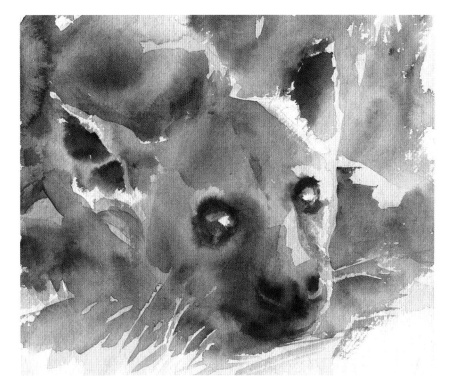

2. The Pigments

Today's artist has more colours to choose from than at any time in history, from the earth pigments that were the earliest colours of all to more modern paints derived from metals and carbon. You will probably find the physical and chemical properties of paints as engaging as the colours themselves, and becoming acquainted with them will certainly make for greater understanding and less guesswork. Painting becomes more manageable as you become better informed, and once you become attentive to the individual characteristics of each pigment you will gain greater control; instead of pushing the paint to do what you want, you will choose a colour suited to the task and allow it to excel in its own strengths. It is not in the artist's interest to have every red, blue or yellow on offer - the important thing is what a particular colour can deliver to a painting.

Snow Flurries, the Purpose
of Winter Coats
30.5 x 30.5cm (12 x 12in)

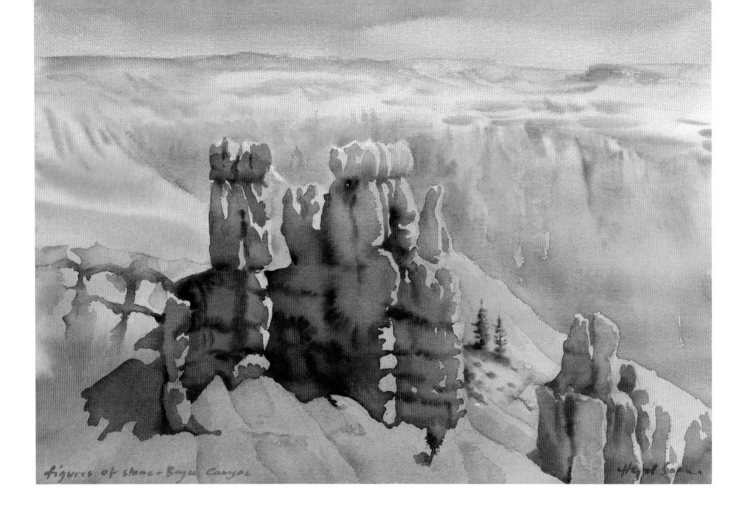

figures of stone - Bryce Canyon

The Making of Watercolours

Watercolour paints are produced by combining finely ground pigment with a binder, usually gum arabic from acacia trees in Africa. The colourless gum dissolves when mixed with water and then acts as a fix to hold the colours in place when the water evaporates. This is why it is possible for the artist to apply layers of tints without disturbing or muddying the colours underneath.

Each pigment reflects or absorbs light in different wavelengths and has a different chromatic intensity. Because the nature of subtractive colour mixing tends towards black, the individual colours of artists' watercolour ranges will be made out of single pigments, or as few as possible, to ensure the brightest, cleanest hues and to limit the number of pigments involved in the painter's mix.

Watercolours come packaged in tubes or pans. In the tube, the paint remains moist, making it easy for the painter to obtain concentrated colour quickly. Pans, which are blocks of paint that are worked with a damp brush to release their pigment, are kept in compartments in a paintbox. A portable box with an attached folding palette is ideal for painting outdoors and travelling; I carry both an enamel box of pans with a folding palette and a selection of tubes. You can buy a paintbox ready filled with the manufacturer's choice but it is better to buy an empty box and add individual pans of your own choice of colour and size.

Earth's Sculpture, Bryce Canyon
35.5 x 45.5cm (14 x 18in)
Imagine the tiny particles of pigment settling on the paper, spread evenly like the pixels on a computer screen. Radiant watercolours like this scene in Utah are made with clear pigments, untroubled washes and minimum disturbance.

Earth Pigments

Millennia ago, cavemen decorated their walls with images made from colours of the earth, from soot and from chalk. Earth colours – which include the ochres, umbers and siennas – remain an important part of the artist's palette today. Essential for their low tinting strength and natural tones, they blend beautifully with other colours without altering them too much. When they are heated they redden in hue – hence the names Raw Sienna and Burnt Sienna, Raw Umber and Burnt Umber.

Some natural earths are still included in artists' ranges, but over the years the sources have been depleted and many are replaced by synthetic iron oxides. However, when you read 'synthetic' you should not think negatively – these chemical equivalents have ensured not only permanence and continuance but also the addition of stunning new colours to the artists' palette.

Music to Catch the Colours, New Orleans
40.5 x 30.5cm (16 x 12in)
The harmonious tonal range in this Jazz scene is built up with the values provided by four earth pigments: Yellow Ochre for the lightest tones, Raw Umber and Burnt Sienna for the mid tones, and Burnt Umber for the darkest tones.

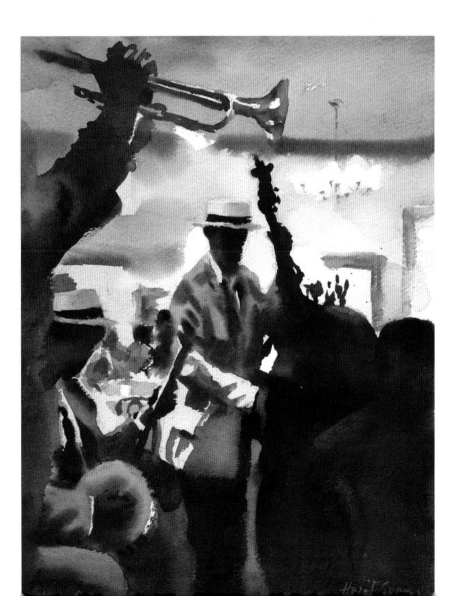

Only Our Shadows
Walk Beside Us
99 x 73.5cm
(39 x 29in)
Thanks to centuries of
devoted colourists and
the requirements of the
automobile industry, we
have the many excellent
and lightfast colours
used in this painting.

Traditional Pigments

The colours manufactured prior to the 20th century are termed traditional colours. Many of those first made in the 19th century came from the discovery of the metals chromium, cobalt and cadmium. The names of these pigments read like poetry – Viridian, Cerulean, Cobalt Blue, Aureolin, Cadmium Yellow, Cadmium Red and Cadmium Orange. The colours based on cadmium pigments have brilliant hues, good coverage and low tinting strength, accompanied by excellent light-fastness and very high opacity.

Prussian Blue was created a century earlier and was accidentally discovered by a German colourist while manufacturing red, while French Ultramarine was the result of a competition between the Germans and the French in the 1820s to replace expensive lapis lazuli with a more economical equivalent. As the name indicates, the French won.

Over the years, several traditional pigments have been discontinued but some have been replaced by modern equivalents of the same hue, for example Indian Yellow.

Carbon Colours

Since the colours of pigments mix together to make black, it is not surprising that scientists discovered they could extract individual colours from the black of coal tar. The first carbon colour, Mauvine, was born in 1856, after which it was only a matter of time before further distillation of coal tar released many more glorious organic transparent pigments, such as Alizarin Crimson, Quinacridone Red, Quinacridone Gold, Perylene Green and Indanthrene Blue. The polysyllabic names of these most recent carbon pigments derive from the chemical process involved and it is thanks to the automobile industry – the requirement that the colour of a car must endure all weathers and remain permanent – that we now enjoy so many dazzling new lightfast yellows, reds and purples.

In the 1950s, when the early pigments were perfected, the manufacturers often prefixed the colour with the word Permanent, for example Permanent Rose and Permanent Sap Green because the chemical names were deemed too complex.

Faded Glory
56 x 38cm (22 x 15in)
Advances in carbon chemistry bring more transparent colours to the artist's palette. The new and redeemed hues Quinacridone Red and Indian Yellow are mixed here to make the radiant pinky-orange of this Venetian façade.

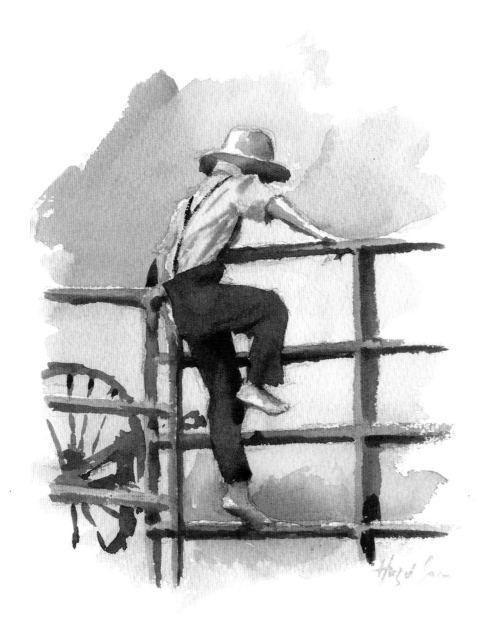

Amish Boyhood

28 x 20cm (11 x 8in)

Artists' watercolours are not inks or dyes which fade quickly. The Yellow Ochre, Viridian, Ultramarine and Burnt Sienna used in this painting are traditional stalwart colours, made to last.

The Science of Pigments

Categorized chemically by whether or not they contain carbon, pigments are divided into two main groups: inorganic or organic. The former pigments include the earth colours and the mineral and metal colours, while the latter are derived from living or once-living substances such as dead trees (coal tar). Each pigment has different characteristics, as the micro particles vary in size, weight, shape, transparency, opacity and intensity. Whether a pigment will deliver a smooth or textured wash, how transparent or opaque it is and the strength of colour it can offer all affect the choice of colours used in a painting.

 Before the 20th century, the artist also had to consider the permanence and lightfastness of pigments as watercolour ranges contained some pigments that changed or faded over time (hence watercolour's reputation as a delicate medium). Now permanence has improved so much that modern watercolour pigments are robust and long-lasting.

Making the Most of the Pigments

When pigment is diluted in water, the micro-fine particles are carried in suspension, enabling the artist to brush the pigment freely over the paper. If the grains of pigment are allowed to settle in an even, natural fashion without undue interference, they create tints and washes of extraordinary allure. Light shines through the pigment layers and is reflected back from the white paper, creating the radiance for which watercolour is famed. Some pigment particles also cause refraction of the light or are transparent like stained glass, adding a unique luminosity.

However, watercolour washes can only shimmer like this if they are not compromised. Destruction of this attractive quality is caused by needlessly dragging the brush back and forth across the paper, preventing the even lie of the particles. Radiance is jeopardized by layering dilute colour in the vain hope of reaching the right tone, and transparency is lost by muddying colours with opaque pigments. The worst error of all is to disturb an elegant wash while it is drying – it forces the granules of pigment into unhappy clumps, luminosity is destroyed and mud results!

As If They Were Not There
25.5 x 30.5cm (10 x 12in)
Always have the courage to stop – don't keep fiddling. Indiscernible boundaries and shifting blends give watercolour its vitality. Too much 'control' would have stolen the charm of ambiguity from this painting of elephants emerging from the African bush.

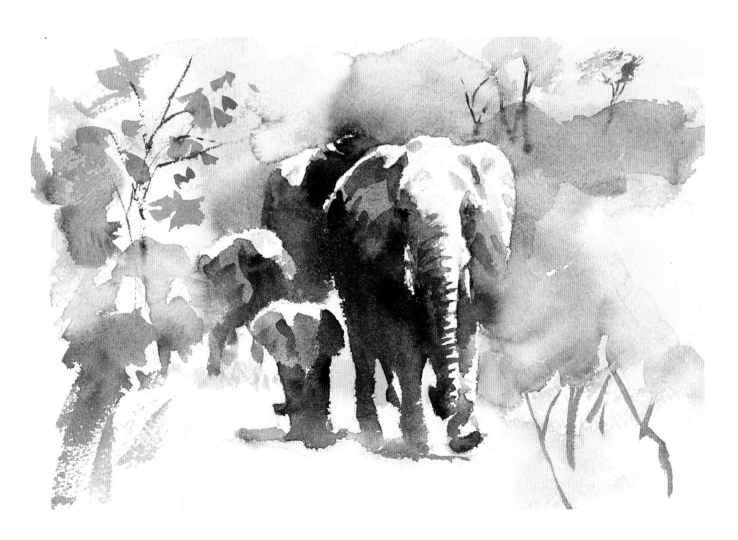

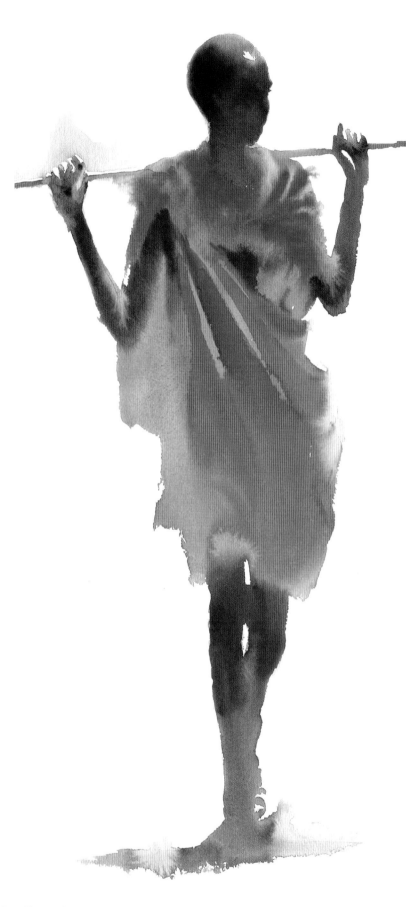

Transparency

Watercolour is celebrated for its transparency, which is its key characteristic. When diluted with water and laid in a thin film on paper, all the colours have this property to a greater or lesser degree. In their concentrated form, some pigments remain transparent in varying degrees and others are nearly or fully opaque. The transparent colours bring radiance, clarity, clean mixing and breadth of cover, while the opaque colours provide brilliance, subtlety, flatter washes, body and covering power. These properties are so important in the mixing and laying of colours that the next chapter is devoted to this characteristic.

Warrior
76 x 51cm (30 x 20in)
The watercolourist needs both transparent and opaque pigments. Here the transparency and high tinting strength of the organic pigment Permanent Rose provides the drape with a radiant pink, while the opaque inorganic pigment of Cadmium Red offers the brilliant red thrown over the shoulders.

Tinting Strength

The ability of a pigment to alter another colour in mixing is called its tinting strength. A high tinting strength has a dominant effect on mixtures, whereas a low tinting strength will not alter the mix significantly. Strong colours need to be added little by little in a mix, otherwise you may find yourself fighting to adjust the hue and mixing will take longer. Higher tinting strength allows for a thinner application of pigment on the paper so, in general, the transparent carbon pigments with their finer particles will have this property. The tinting strength of some inorganic colours and most earth colours is lower and allows for their renowned subtlety and quieter modification in mixing.

To make this grey-green blend for the acacia tree, a greater amount of Cerulean Blue than Aureolin is required, since the former is a colour of moderate tinting strength and the latter is stronger. Only a dash is needed of the even stronger Winsor Violet that makes the darker tones.

Staining and Lifting Properties

Watercolour is essentially a staining medium and relies on the penetration of pigment into and between the fibres in the top layer of the paper to achieve stability. Colours made of very fine particles tend to stain more than others because they can creep into smaller gaps; the traditional organic colours Prussian Blue and Alizarin Crimson are particularly strong stainers. However, many of the inorganic and earth colours, with their larger particles and granulating properties, can be lifted to varying degrees - for example Ultramarine, Burnt Sienna, Raw Sienna and Cobalt Blue. This property is extremely useful for introducing lighter tone, shifting pigment and restoring highlights. It does also mean that these pigments can be shifted unintentionally, either in layering, with excess water, or with heavy-handed brushwork.

Lifting-off Technique

Intentional lifting is done with a clean damp brush, a clean rag or, for broad areas, a sponge. First loosen the pigment with a gentle rubbing motion or a dash of water, then move it with the brush or dab off with a rag or sponge. You must keep these clean otherwise you will rub the lifted pigment back into the paper.

Apart from reintroducing light, lifting can soften the hard edges of a wash and, if done with care, remove unwanted seams. Paper surfaces will react differently, but with careful repetition the residue of some colours can be wiped almost entirely away. To remove large sections or even whole paintings, simply put the paper under a cold tap; it can then be dried and repainted.

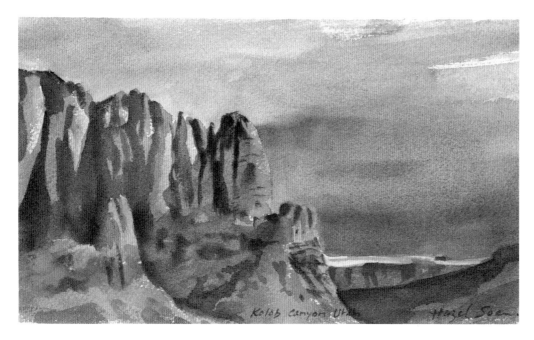

Pink and Turquoise Kolob Canyon
20.5 x 12.5cm (8 x 5in)
The granulating property of Cerulean Blue is exploited here to emphasize the coarse textures of the monoliths overlooking the canyon.

Granulation

Most pigments deliver smooth washes, but the pigment particles of some colours are sedimentary and settle in a mottled fashion. This characteristic, called granulation, creates an attractive textural effect as the pigment settles unevenly on the paper or in the troughs and valleys of the paper surface. This is found mainly in the heavier inorganic pigments.

Raising Dust Rodeo-style
56 x 51cm (22 x 20in)
Here, I chose the colours Burnt Sienna, Burnt Umber and Ultramarine (Green Shade) for their lifting properties. I could paint the mantle of dust freely and then lighten it with the aid of a sponge to enhance the hazy appearance.

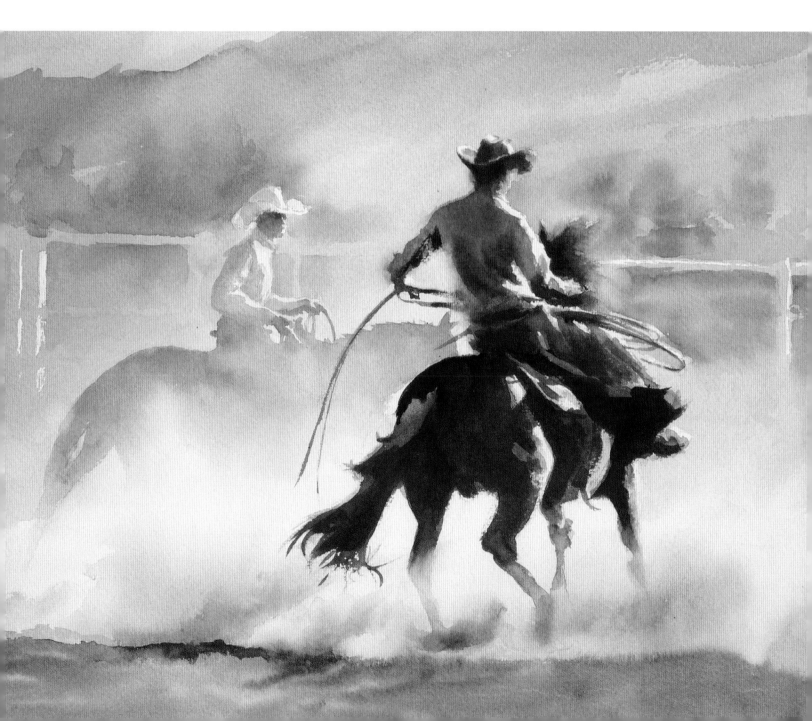

3. Transparency and Opacity

The use of transparent and opaque colours underpins radiant watercolour. With this transparent medium, most glazes presume a light ground and pigments vary in relative transparency and opacity to offer you a multitude of options from fully transparent to semi-transparent, semi-opaque or very opaque. All these properties are essential to the watercolourist; the transparent colours offer clear, radiant washes and can achieve deep darks, while opaques are prized for their brilliant hues, subtlety and covering power. The cause of lifeless or muddy watercolours is often just the misuse of opaque colour in a dark mix or transparent glaze, so getting to know the property of your pigments in this respect will save you a lot of heartache.

Afternoon Tea at the Ritz
20.5 x 20.5cm (8 x 8in)

Discovering the Difference

Pigment manufacturers state the transparency or opacity of each paint in their printed colour charts and on their websites; sometimes it's indicated on the tube, too. However, you won't always have this information immediately to hand, so it's useful to know how you can tell the difference from the pigments themselves.

The first indication of whether a pigment is opaque or transparent is often the name. You might guess that a pigment derived from metal would be opaque because it is likely that the particles would be heavier and denser than organic pigments of a similar hue. You would be right: a Cadmium prefix denotes opacity, Titanium White is opaque and the Cobalt colours are semi-opaque or semi-transparent. On the other hand, the pigments made from carbon chemistry have lightweight particles, so those with polysyllabic names, such as Quinacridone, or the prefix 'Permanent' indicate transparency.

You can often see the property by the appearance of the pigment in concentrated form, so the next clue is found in the palette. Unless they are virtually black, the opaque colours do not have the depth of tone to make blacks. They are lighter and look like the hue in their name, for example Cerulean Blue looks blue and Cadmium Red looks red – they can never reach a darker tone and when diluted they maintain a consistent hue. Conversely, the transparents look very dark in their concentrated form and their diluted colour cannot necessarily be foreseen from their appearance in the pan. Prussian Blue, Winsor Violet and Alizarin Crimson, for example, look almost black in the palette but dilute to tints of pale blue, mauve and pink, respectively.

It is harder to guess this property in yellow because it is such a light-toned hue. Aureolin and Indian Yellow are transparent colours but they also look yellow in concentration. This does, however, tell you that they will be too light to contribute to deep black. If you want a truly transparent yellow to help you mix a black, look for yellows that look brown in their concentrated form, such as Quinacridone Gold and Raw Umber.

If the transparency or opacity of a colour is still in doubt, take a little of the pigment on the brush and rinse it off in a clear pot of clean water. The transparent colours will tint the water, while the opaque colours will cloud the water and the heavier particles will eventually sink to the bottom.

Manufacturers classify the pigments of artists' quality colours as transparent (T), opaque (O), semi-opaque (SO) or semi-transparent (ST). I use the same classifications in the chapters on individual colours.

Heading to Water

76 x 25.5cm (30 x 10in)

Semi-opaque Yellow Ochre shapes the elephants in this painting. Rinsing this pigment off the brush clouds the water in the pot, so the ensuing applications of transparent Burnt Sienna and Winsor Violet require clean water to achieve clarity.

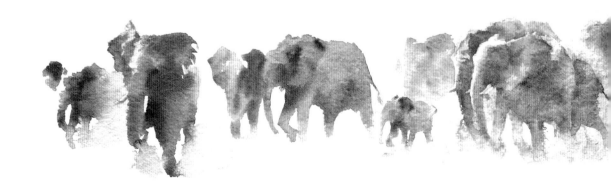

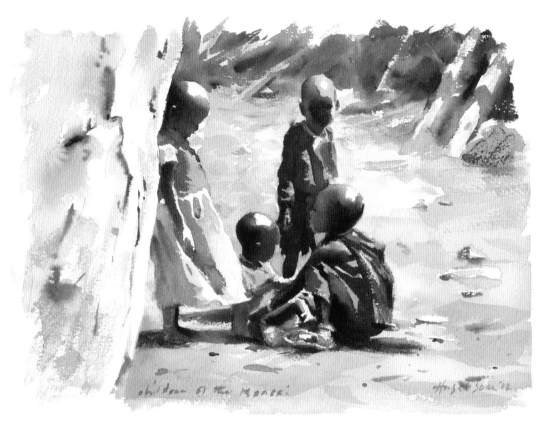

Africa's Children
28 x 38cm (11 x 15in)
Brown Madder, Alizarin Crimson, Winsor Violet and Prussian Blue are dark in their concentrated forms. This indicates that they are likely to be transparent and therefore well suited to paint both the pale tints and richer hues needed to portray these children.

Dispersal

As they are variable in weight, pigment particles disperse at different rates. When you are blending colour in a wet wash, the transparent pigments with smaller, lighter particles will disperse quickly, while the heavier, opaque pigment particles move more sluggishly. This knowledge is extremely useful, since you can anticipate whether a colour will race out into a wash, blending freely, or crawl sedately forward and hold its own; you gain control and the ability to judge how much water to mix with the pigment to achieve the effect you want.

The lightweight transparent colours Permanent Rose and Permanent Sap Green blend freely and easily with each other on this stem (below).

Above, the heavier particles of the opaque Cadmium Red creep tendril-like into the prevailing wash of Indian Yellow.

Retaining Transparency

Transparent colours can be laid over each other in successive glazes to alter hue and intensify tone without also compromising transparency. However, if you paint too many layers you will eventually fill in all the spaces between those minute particles and block out the light reflecting back from the white paper, so you need to reach dark tones with the fewest possible number of layers.

The opaque colours, with their flatter, denser washes, are at their most transparent in a single film. The first wash is the freshest; in glazing, their covering power erodes transparency. Opacity serves to modify, tone down or obliterate a colour beneath, but this essential trait also muddies or dulls colours if used without care.

Watercolours are generally built up from light to dark. The dilute tints and washes remain transparent whether the pigments are opaque or transparent and you can use either property to sway the atmosphere in a painting. The muted luminosity of opaque tints sits further back to the eye than the radiant clarity of transparent glazes, so this effect can be used to create depth, especially in landscape painting.

Santa Barbara Lifestyle
38 x 23cm (15 x 9in)
The slight opacity of Cobalt Blue keeps the bright blue sky and distant mountains at the back of the painting. The successive layers of paint that shape the palm trees and café features are applied in single films of wet-into-wet colours to prolong transparency.

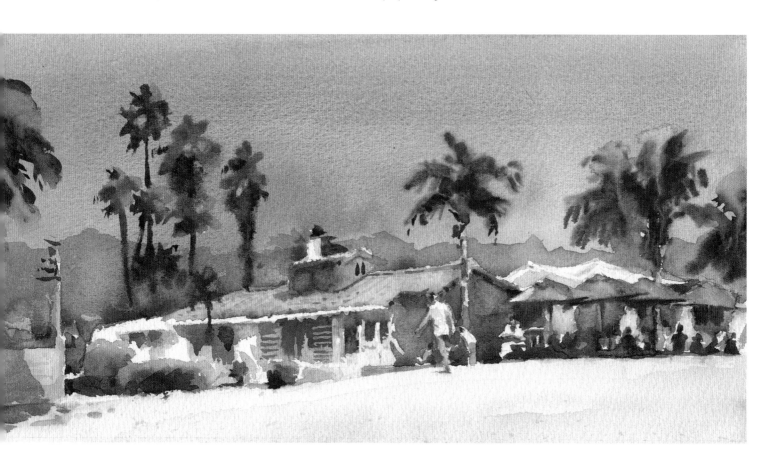

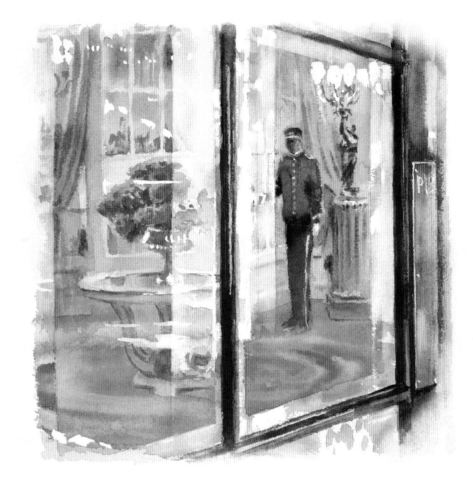

Entrance to the Ritz Hotel, London
20.5 x 20.5cm (8 x 8in)
While the highlights on the glass doors are mostly reserved as white paper, some are added with Titanium White paint – but you probably cannot tell which is which.

Opacity and Highlights

The opaque colours are essential for their brilliant and subtle hues and the power to inject prominent colour wet-into-wet. The light-hued pigments can also introduce lighter tone and restore highlights. The covering power of Titanium White, Lemon Yellow and Cerulean Blue, for example, enable the application of light colour on top of darker washes. Knowing that you have this facility to restore light allows you to go boldly ahead with broad washes to establish overall tonal balance and then insert small lighter details later. Opaque white watercolour will never be as bright as the untouched white paper, but it will appear as light within or beside a tone darker than itself.

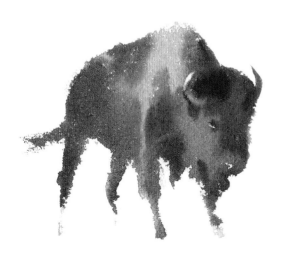

A whisker of opaque Titanium White restores the light on the bison's horn, allowing the shape of the torso to be painted without worrying about reserving white paper for small details.

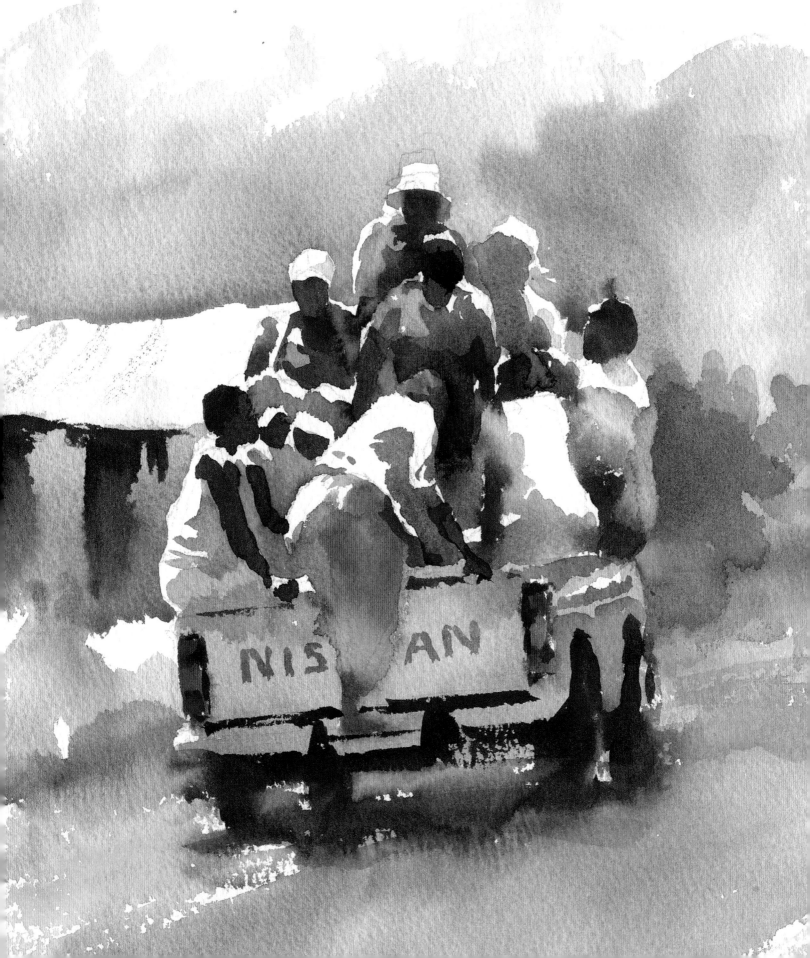

4. Mixing Colours

The colouring of a watercolour painting is achieved by bringing pigments together in combination. This chapter covers the three main methods: layering, blending and mixing in the palette. The aim of colour mixing is to create the largest number of options from the smallest number of colours and at the same time be able to reach the colours you want for the painting. 'Less is more' is the watercolourist's maxim, as paintings gain coherence and appear more colourful if the selection of colours is limited. Since pigments mix together to go towards black, it is easy to see that too many colours would result in muddiness. A choice of warm and cool versions of the hues and varying degrees of transparency or opacity will enable you to mix your colours successfully from very few pigments.

Rush Hour, African Style
33 x 30.5cm (13 x 12in)

Brush, Palette, Water – Action

Mixing pigment with water in the palette distributes the pigment particles evenly in the dilution and enables you to load the brush. Achieving the right consistency and the right amount is important. For broad washes, load the body of the brush by mixing at an angle to the palette; for small details, load only the tip. A sloped palette with several wells is best as it allows wetter mixtures to pool at the bottom of the slope while drier mixtures stay at the top, making it quicker for you to dip into the consistency of paint that you want. With this in mind, squeeze any tube paint you require on to the sides of wells or at the top of slopes so that it remains neat and dry, instead of being diluted where water gathers. I recommend a china or enamel palette since plastic repels water, making it hard to see the real tone of the mix.

Mixing may be guesswork in the early days but it soon becomes easier with practice. Time spent getting your mix to the right consistency and in the desired hue and tone is never wasted – it is something that cannot be hurried. Washes generally look darker wet than dry, so check the mix by testing the colour on a spare piece of paper before applying it to the painting. A piece of kitchen towel under the palette is also useful to soak off excess water from the brush. Radiant tints require clean water; even slightly tinted or clouded water will dull an opposite colour and compromise transparency.

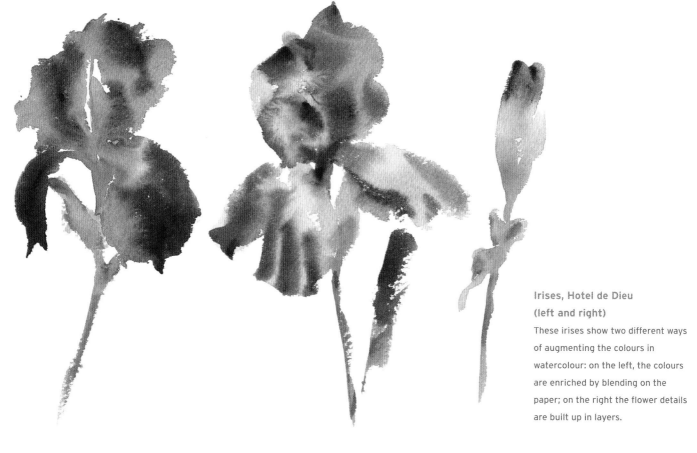

**Irises, Hotel de Dieu
(left and right)**
These irises show two different ways of augmenting the colours in watercolour: on the left, the colours are enriched by blending on the paper; on the right the flower details are built up in layers.

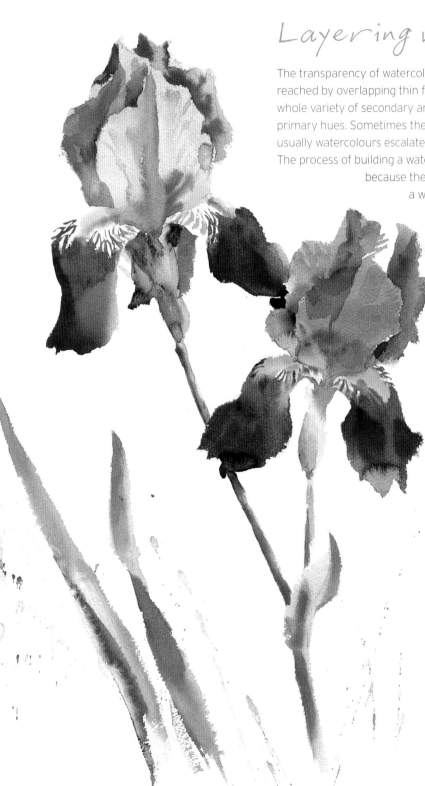

Layering with Glazes

The transparency of watercolour means that an infinite number of colours can be reached by overlapping thin films of colour, termed glazes, washes or tints. A whole variety of secondary and tertiary colours result from overlaying a few primary hues. Sometimes the final hue or shade of a colour is directly applied, but usually watercolours escalate in a sequence from light to darker hues and tones. The process of building a watercolour in layers is termed wet-on-dry technique because the colour underneath has to be completely dry before a wet glaze is painted on top; the gum arabic must be allowed to set so that it can protect the pigment already in place, otherwise the drying particles will be disturbed and the appearance ruined. The broadest and lightest washes are usually applied in the early stages and darker hues added with overlapping glazes.

Glazing can produce colours that are more radiant or subtle than if the same two colours were mixed in the palette. For example, Yellow Ochre mixed with Prussian Blue makes a green, but overlaid in thin glazes they both remain subtle warm and cool hues respectively (see *Sleeping on Sand*, p.17).

Contrasting hue, tone and temperature in layering enlivens the overall colouring. For example, a background sky could be painted with a grubby pale yellow tint and yet look radiant adjacent to a cool dark purple feature painted on top.

Blending on the Paper

One of the most charming characteristics of watercolour painting is the blending of wet colours on the paper; they mingle in a single film and so retain the transparency of a single layer. With wet-into-wet technique, a wash is laid and subsequent colour is added into the wet paint so that the hues mingle to become one varied wash or the second colour is laid beside the first colour to meet and make a third. A lot of my paintings are made using this technique, allowing pure unmixed colours to blend naturally on the paper. Only in the later stages are the colours mixed together in the palette to add increased tone and intensity.

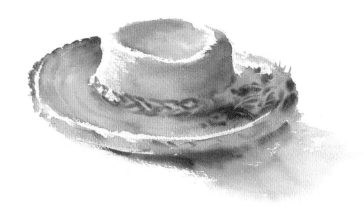

Hazel's Hat
12.5 x 18cm (5 x 7in)
Adding more intense colour wet-into-wet to a paler tint of the same or similar hue is a quick and effective way to suggest increases in tone. Here Burnt Sienna is added into Yellow Ochre to indicate the shadows behind the straw fronds and between the plaited strands.

Going to Market
15 x 25.5cm (6 x 10in)
Wet-into-wet blending multiplies the number of hues and adds vitality from the movement of pigment across paper. Indian Yellow, Permanent Rose, Cadmium Red, Cobalt Blue and Cerulean are blended to paint these figures.

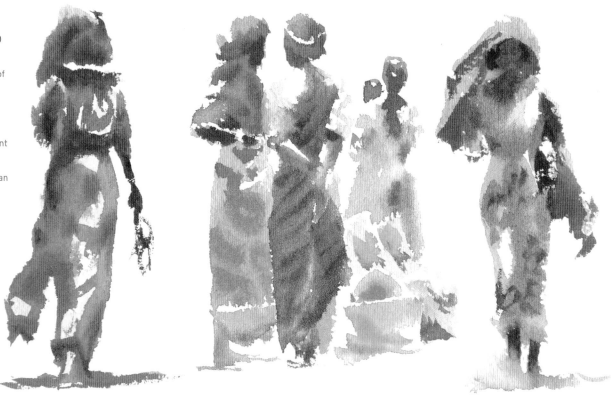

Playground

76 x 76cm (30 x 30in)

Quinacridone Gold, Prussian Blue and Quinacridone Red are blended here on Khadi paper to make secondary and tertiary colours. I dropped in clean water to encourage backruns. The long-fibre cotton Khadi paper takes longer to dry than regular cotton papers, allowing plenty of time for wet-into-wet mixing.

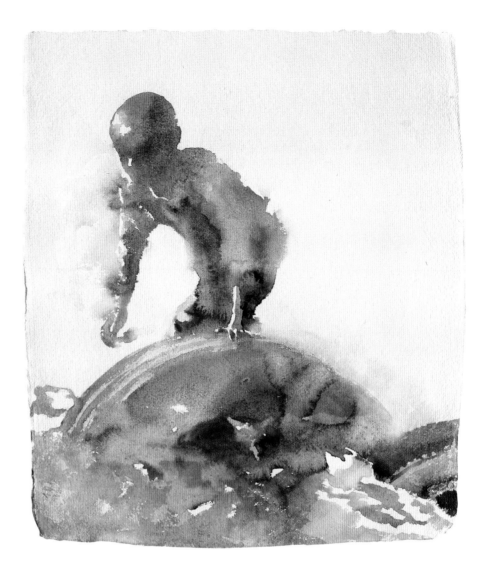

Diffusion

Success in blending wet colours comes from the consistency of the paint and the timing of application. The first wash must be wet when the next colour is added but not so wet that the paint pools; the second colour must be less dilute than the first to take into account the water already on the paper. Once a second colour has been added, the mix on the paper is even wetter, allowing more time before drying for subsequent wet-into-wet applications.

When you add the colour, try not to disturb the preceding wash – the particles are settling down and gradually drying, and if you disturb them they will not be happy. Adding the subsequent colour into the damp wash at the right moment and in the right place and then leaving it alone to spread brings the best results. In small areas, usually all you need to do is touch the second colour into the wet paint with the tip of the brush and let diffusion between the two pigments occur unassisted. The added pigment particles speed or amble outward into the prevailing wash, depending on their particle size and weight. I enjoy watching the transparent pigments rush to mingle, while the heavier opaques claw outward in delicious tendrils of colour. Occasionally the mingling has to be coaxed and this can be done with a gentle stroke of the brush or by harnessing gravity – tilting the paper in the best direction to encourage the flow.

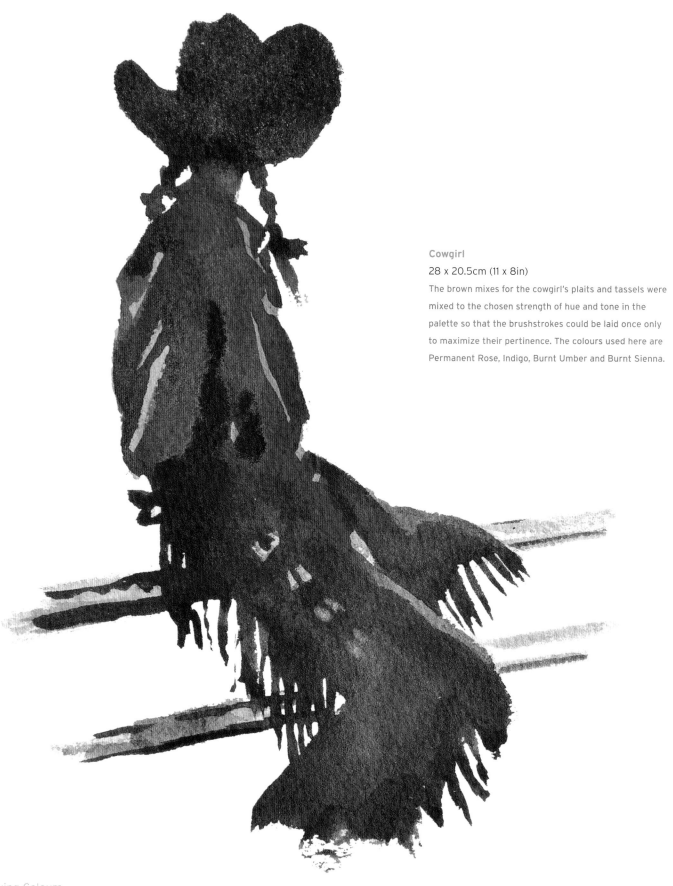

Cowgirl

28 x 20.5cm (11 x 8in)

The brown mixes for the cowgirl's plaits and tassels were mixed to the chosen strength of hue and tone in the palette so that the brushstrokes could be laid once only to maximize their pertinence. The colours used here are Permanent Rose, Indigo, Burnt Umber and Burnt Sienna.

Mixing Colours Together in the Palette

Apart from the primaries, colours can be created by mixing two or more pigments together in the palette. The mix is then applied directly to the painting. Primary hues mix to make the secondary and tertiary colours; opposites mix to make greys and browns; warm and cool colours adjust temperature. The combinations are limitless. Most of my paintings are made with pure unmixed colour washes in the early stages and as the painting progresses two or three colours are mixed together to reach the darker tones.

As pigments have different strengths, colour mixing is a matter of fine tuning. Turning a hue, tone or temperature up or down usually requires very little pigment, especially those of high tinting strength, so add small amounts little by little to find the desired colour. Since luminosity is more achievable from a single film than from several weaker layers, it pays to take your time in the palette and only go to the paper when you think you are ready with the right colour and consistency loaded on your brush. Aim to deliver the most significant contribution you can with each brushstroke so that you brush the paper as few times as possible.

Easy Virtue at the Jubilee River Pageant

12.5 x 20.5cm (5 x 8in)

As the brushmarks for the ripples look their best as a single stroke, I made sure I
found the right tone and hue in the palette before applying the mixes to the paper.

Colours in Combination

Any combination of red, yellow and blue will give you a large range of colours and tones to which you can add if necessary. Colours create the mood and atmosphere conveyed by the painting. Everything in a painting is relative, so colours are not mixed to imitate individual hues – they are chosen in relation to each other. Look for the predominant colour of the subject and its bias, and gear your selection around it.

I usually start with the blue – I look at the mauves, greens and darks I need to mix, then choose a blue best suited to create the particular colours I want. A warm blue such as Ultramarine (Green Shade) will make bright violets and dull greens, while a cool blue like Prussian Blue will make duller mauves and brighter greens. A transparent blue can reach black, but an opaque cannot.

Choose your yellow according to the greens, browns, oranges and darks. A cool yellow such as Aureolin will mix bright green and subtle orange, while a hot yellow such as Indian Yellow makes a more natural green and a brighter orange. A transparent yellow can contribute towards black.

Once you have settled on two of the primary colours the third is much easier. In this case you would choose the red that mixes best with the yellow or blue to make the oranges, browns, violets, and darks you want. A warm red such as Cadmium Red makes a bright orange, while a cool red, for example Permanent Rose or Alizarin Crimson, makes clean violets.

Familiarity with colour combinations is gleaned from practice in the palette, but throughout this book the colour names are given in most captions so you can see how particular combinations work and how few colours are often needed.

John Wayne Country, Monument Valley
30.5 x 40.5cm (12 x 16in)
In this painting I chose Ultramarine (Green Shade), a warm transparent blue, for the sky and to mix the mauves and dull greens. Indian Yellow is included for the warm tint to the base of the sky and to mix with Permanent Rose for the landscape, and all three mix together for the gingery brown and dark shadows of this famous monolith in Monument Valley.

Choosing the Palette

Most artists have a basic set of about 16 colours from which they make their choices. You need a cool and warm version of each of the primaries - mine are listed in the box, right. In the following chapters you will see alternatives, and there are even more to choose from in a complete watercolour range. Include some earth colours for their subtlety, low tinting strength and natural tones; mine are Yellow Ochre, Burnt Sienna, Raw Umber, Burnt Umber and Light Red. I have recently added the similar but transparent hue Brown Madder. I also include Cobalt Blue and Cerulean Blue for their unique hues, and Indigo and Sepia for their intense depth of tone. I carry tubes of Titanium White for its covering power, and Cadmium Yellow for its brilliance. My palette also has space for colours I use less often: two ready-made greens, Viridian and Permanent Sap Green, the highly transparent Quinacridone Gold and the opaque Lemon Yellow. In total there are 22 colours in my travelling palette, enough to paint the world!

The following chapters look more closely at the properties of individual yellows, reds, blues, greens and browns and will help you create your own palette. Have fun!

ULTRAMARINE
PRUSSIAN BLUE
AUREOLIN
INDIAN YELLOW
CADIUM RED
PERMANENT ROSE OR
ALIZARIN CRIMSON

Rio Ognissanti Venice

Venice Resting

30.5 x 40.5cm (12 x 16in)

The blue of the canvas determined the choice of blue - Ultramarine - while the Venetian walls called for a reddish-brown (Brown Madder). Since these two pigments do not mix to make the black on the gondola I added Indigo to enable the intense darks and blue greys. Viridian was popped into the reflections to encourage the Brown Madder to appear to veer towards red through comparison.

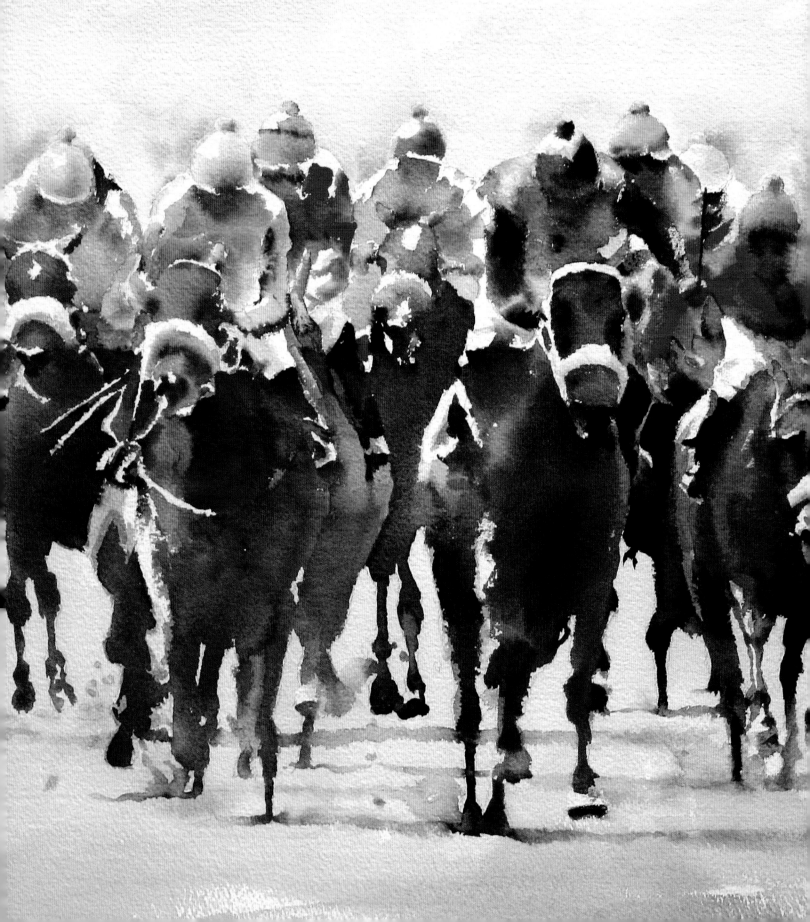

All the
Colours
of the
Rainbow

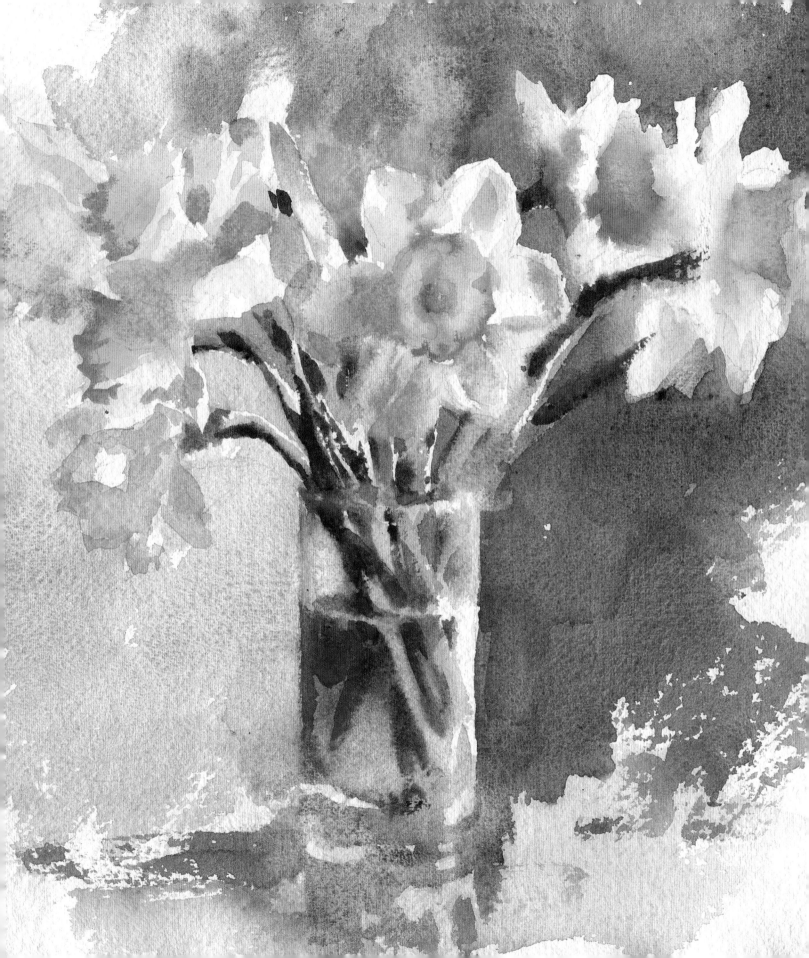

5. The Yellows

Yellow is the lightest in tone of the three primary colours. Since watercolours are generally painted from light to dark, it is often the very first colour to be laid, so it is the ideal starting point for our journey into the palette.

The temperature of yellow can exert a strong influence on the mood of a painting; a warm yellow is a lively, cheerful colour, brazen or mild, while cool yellows are more acerbic, fresh and clean. Despite its pale hue, yellow comes in a broad range of shades from the lighter opaque yellows to the darker earth pigments. Most yellows look like yellow in the palette, but the truly transparent ones, such as Quinacridone Gold, are brownish in their concentrated form even though they can be diluted to the palest yellow tint.

Yellow is the Colour of Spring
30.5 x 30.5cm (12 x 12in)

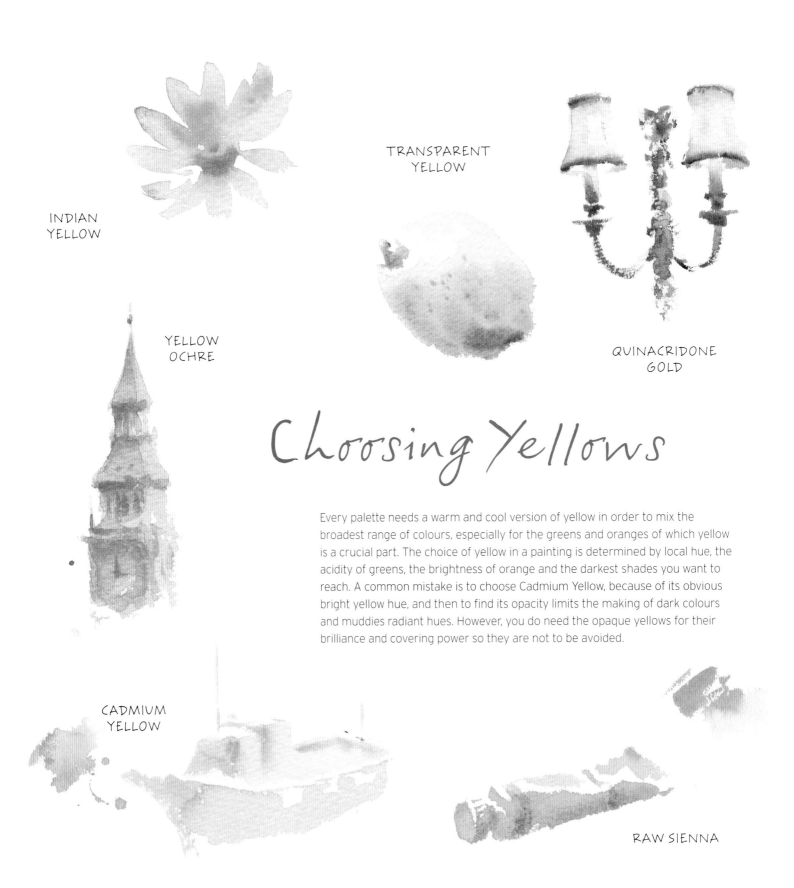

INDIAN
YELLOW

TRANSPARENT
YELLOW

QUINACRIDONE
GOLD

YELLOW
OCHRE

Choosing Yellows

Every palette needs a warm and cool version of yellow in order to mix the broadest range of colours, especially for the greens and oranges of which yellow is a crucial part. The choice of yellow in a painting is determined by local hue, the acidity of greens, the brightness of orange and the darkest shades you want to reach. A common mistake is to choose Cadmium Yellow, because of its obvious bright yellow hue, and then to find its opacity limits the making of dark colours and muddies radiant hues. However, you do need the opaque yellows for their brilliance and covering power so they are not to be avoided.

CADMIUM
YELLOW

RAW SIENNA

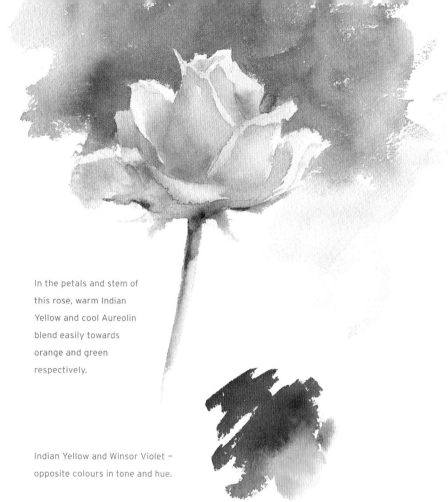

In the petals and stem of this rose, warm Indian Yellow and cool Aureolin blend easily towards orange and green respectively.

Indian Yellow and Winsor Violet – opposite colours in tone and hue.

Yellow in Contrast

Yellow and violet are opposite colours in both hue and in tone and therefore enjoy dynamic counterpoint. The dominance of the tonal divide, however, can usurp the potency of the individual hues, so a warm blue, milder in tone, often provides a more gentle but vibrant foil to yellow.

It may sound strange to say that yellow can be used to brighten a blue sky, but a dilute tint of yellow painted above the horizon makes the blue appear more vivid. A pale yellow of opposite temperature bias has the most effect and prevents the sky turning green. If the blue is cool, use a warm yellow; if the blue is warm you can use either cool or warm yellow.

Old Faithful
25.5 x 28cm (10 x11 in)
In this quick sketch of the famous geyser erupting in Yellowstone Park, the Yellow Ochre brushstrokes in the foreground and the Ultramarine (Green Shade) of the sky offer a lively contrast of hue. The two colours mix well together to make the dull dark green that divides them.

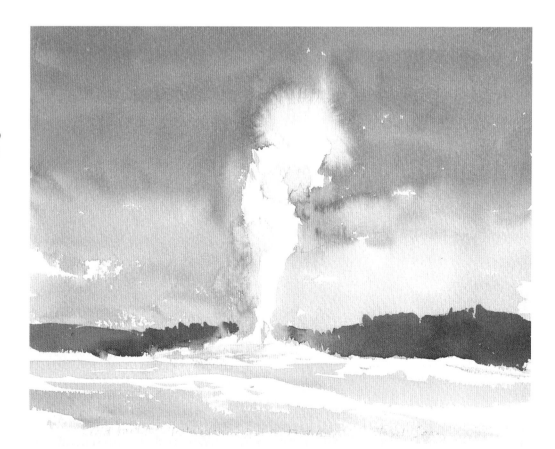

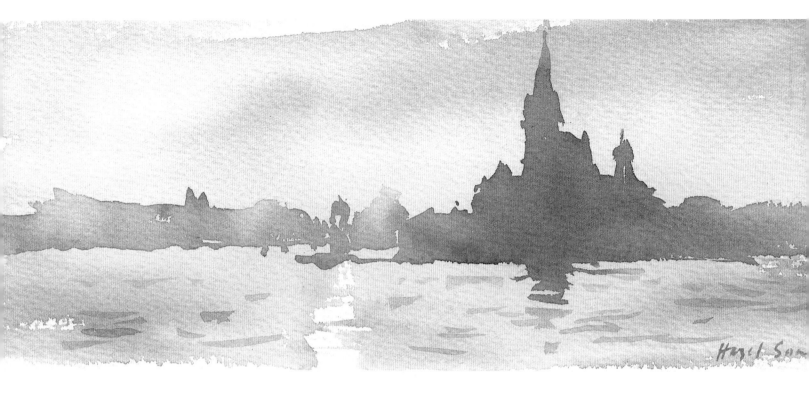

Rendezvous with Sunrise

12.5 x 30.5cm (5 x 12in)

Opposite colours Indian Yellow and Winsor Violet are
perfect foils for painting a sihouette. Brushed on to
damp paper and allowed to blend for sky and water, the
two colours are then mixed together in the palette for
the silhouette of San Giorgio church.

Mixing and Blending Yellows

Yellows mix with reds to make oranges and with blues to make greens. They are
also part of browns and greys. Mixing yellow with violet, its opposite colour, makes
attractive browns, ideal for two-colour combinations, for example subjects in
silhouette. Blending yellow wet-into-wet with red and blue, or with a violet made
from mixing red and blue, adds pleasing variety to grey washes. Because yellows
are light in tone, they contribute less to darks and will only make jet black if they
are fully transparent, such as Quinacridone Gold and Transparent Yellow. Despite
their dark appearance, these dilute to lovely pale gold and acid yellow.

 To use yellow to plant lighter tones and brighter hues into darker colours you
need a fully opaque yellow such as Cadmium Yellow. The transparent yellows
Aureolin and Indian Yellow may look as bright as Cadmium in their concentrated
form but their transparency means they add yellowness (that is, turn a colour
towards orange, green or brown) rather than lighten tone.

The shape of the elephant is painted with a pale yellow wash. Such a light tone supplies a wetting agent and is easy to correct. Indian Yellow is the warm undertone here, into which Alizarin Crimson mixed with Prussian Blue is added to turn the elephants to a colourful grey.

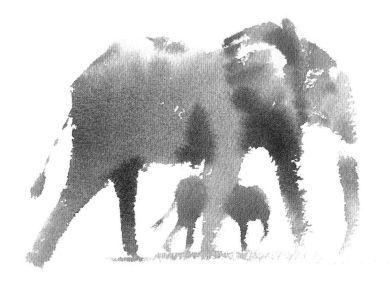

Hidden Secrets – St Trophime, Arles
28 x 38cm (11 x 15in)
Yellow Ochre is the ideal colour for the warmth of this stone colonnade. Diluted, and of low tinting strength, it does not compromise or muddy the darks created with the two cool colours Alizarin Crimson and Prussian Blue.

Indian Yellow (T) warm

Indian Yellow is a marvellous transparent warm and sunny yellow. It was once made from the urine of Indian cows fed exclusively on mango leaves, but this practice became unacceptable. Since the early 20th century alternative organic pigments have been synthesized to match the hue and in recent years they have become as lightfast. Dilute washes of Indian Yellow provide a glowing undertone, while strong mixes approximate to a rich primary yellow. Being warm, it mixes well with reds to make oranges and with reds and blues to make warm browns and greys. I mix it with Permanent Rose to arrive at a transparent red, with Cadmium Red for a bright orange and with Winsor Violet to make delicious browns.

The warmth (redness) in Indian Yellow mixed with blue helps to create subtle and natural-looking greens that are ideal for foliage. The greenest mix occurs with a cool transparent blue, such as Prussian or Winsor Blue. The warmer the blue or the less transparent (for example Ultramarine or Cobalt Blue, respectively) the duller the green becomes. I often use this yellow in three colour combinations.

Under the Southern Sun
25.5 x 38cm (10 x 15in)
The warmth of Indian Yellow infuses this image of my sister basking in the sunlight outside my studio in Cape Town. Cadmium Red, French Ultramarine and Burnt Umber, also warm colours, keep the heat turned up.

**Angles of Africa,
Crescent Island**
28 x 40.5cm (11 x 16in)
In this landscape sketch, Aureolin mixes with the Prussian Blue used for the sky to create the brightly lit green for the grass. Being a transparent yellow it is able, with Alizarin Crimson and Prussian Blue, to contribute to the purply blacks of the tree trunks, limiting the palette to three colours.

Aureolin (T) cool

An exquisite cool transparent yellow made from cobalt, Aureolin is a traditional pigment dating from 1862. Its cool glow replicates the colour of sunlight coming through green leaves. I often use it as a pale undertone beneath darker washes, for example on an elephant's hide or as a thin film under a landscape setting or at the base of a sky.

Aureolin mixes with Prussian Blue to make bright greens, and as both have high tinting strength very little pigment is needed of either. Mixed with Alizarin Crimson, Aureolin makes subtle and quiet oranges ideal for cool Caucasian flesh tones and red landscape soils. As it becomes rather opaque in its dense form, too much Aureolin in a mix can make it muddy and lifeless.

If white paper looks too bright after the removal of cream-coloured masking fluid, I often tint the unpainted paper with pale Aureolin. The creamy tint replicates the colour of masking fluid and restores the tonal balance.

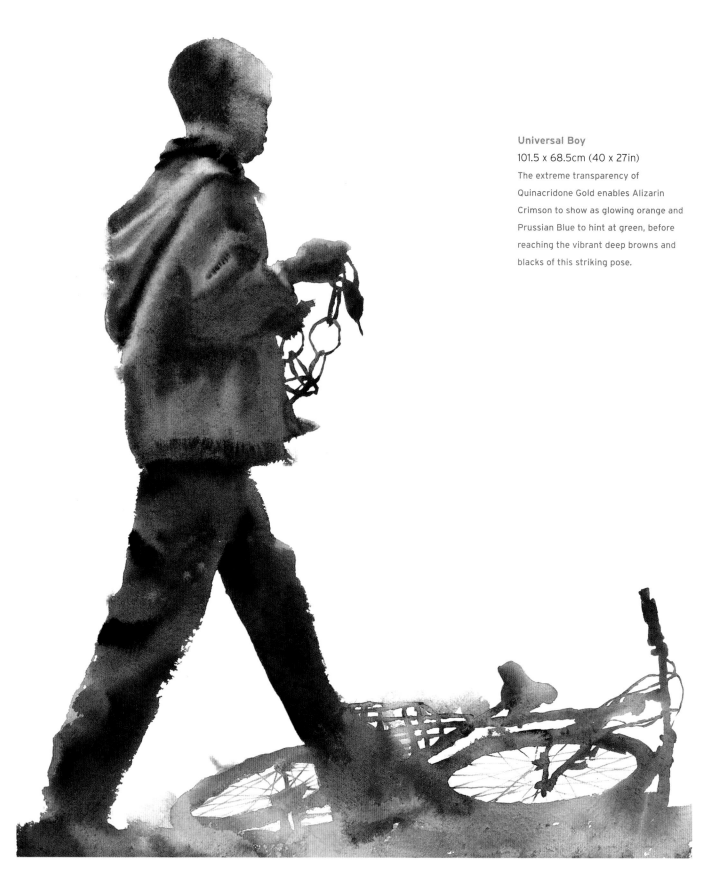

Universal Boy
101.5 x 68.5cm (40 x 27in)
The extreme transparency of
Quinacridone Gold enables Alizarin
Crimson to show as glowing orange and
Prussian Blue to hint at green, before
reaching the vibrant deep browns and
blacks of this striking pose.

Quinacridone Gold (T) warm

A warm but strident yellow, Quinacridone Gold does indeed look golden in its concentrated form yet dilutes to a delicate yellow tint not unlike Yellow Ochre. It was a latecomer among the carbon pigments and has tinting strength and staining properties. Being highly transparent, it can be an ingredient of black, especially if mixed with other carbon colours such as Quinacridone Red and Indanthrene Blue. I find its intensity a bit harsh in its dilute form, and rather acid for greens, but it is wonderfully rich for stronger, darker mixes.

Transparent Yellow (T) cool

The cooler version of a completely transparent yellow is named by its property in the Winsor & Newton range. It is a pungent staining yellow with a delightful hue veering to green and so mixes well for foliage. I find it does not go very far and a squirt is quickly used up in the palette, making other yellows more practical in the field.

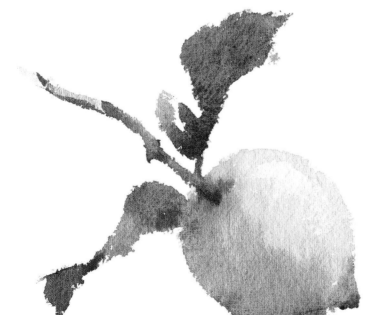

The cool acidity of Transparent Yellow is ideal for painting this ripening lemon and its leaves. Cobalt Blue and Alizarin Crimson turn the yellow to greens and browns.

Cadmium Yellow (O) warm

Cadmium Yellow is a traditional pigment introduced in 1846, several years after the discovery of the metal in 1817. It has been a mainstay of the artist's palette ever since, coveted for its brilliant hue, high opacity, moderate tinting strength and great permanence. It comes in three different tones and temperatures, Cadmium Yellow Pale, Cadmium Yellow and Cadmium Yellow Deep. The paler colour is the coolest of the three but all supply the painter with warm, bright, vibrant yellows. Because it is opaque, the brilliance of the hue is seen at its most dazzling in a single film. It is very assertive introduced wet-into-wet and spreads slowly. Its density and opacity overcome even its opposite colour and enable the watercolourist to add lighter tones on top of darker shades.

Sadly, this lovely yellow is frequently the cause of muddy watercolour paintings because beginners do not realize it is opaque and mix it with blue to make green. Repeated layers end up as sludge. In its dried form on the palette it is hard to tell the difference between the Cadmium Yellows and Indian Yellow or Aureolin, so I buy it in a tube to keep it thoroughly separate from my regular transparent yellows, then it cannot be picked up from the palette by mistake.

Opaque Cadmium Yellow can introduce a lighter tone on top of even its opposite, violet, whereas the transparency of Indian Yellow can only darken the tone and turn the mix toward brown.

Lemon Yellow [Nickel Titanate] (O) cool

Matching the hue of a lemon in the sun, Lemon Yellow is a cool, usually opaque pale yellow. I apply it in small flecks of neat colour to create warm, lively highlights on darks. (As an alternative I mix Aureolin with Titanium White). I rarely use it in mixing, but its weak tinting strength does make charming light, bright greens. Because it is often supplied in ready-made palettes it is another opaque yellow that beginners mix ill-advisedly with blues to make greens which may end up dulling layers and blends.

Lemon Yellow is used for the palest yellow petals of this daffodil.

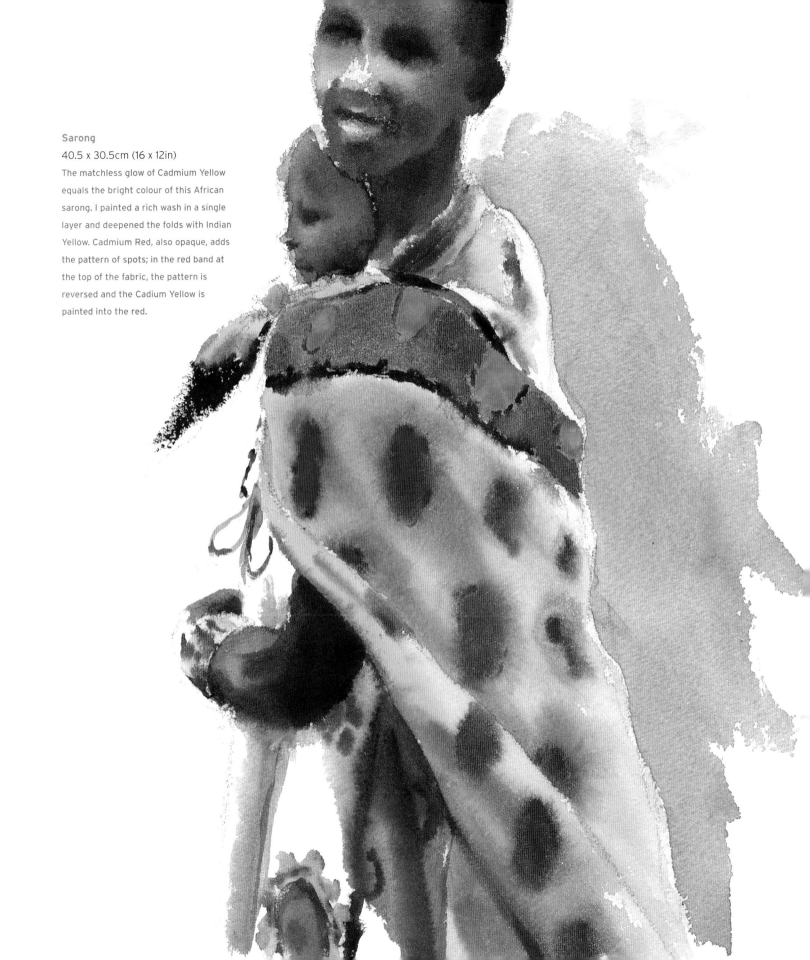

Sarong

40.5 x 30.5cm (16 x 12in)

The matchless glow of Cadmium Yellow equals the bright colour of this African sarong. I painted a rich wash in a single layer and deepened the folds with Indian Yellow. Cadmium Red, also opaque, adds the pattern of spots; in the red band at the top of the fabric, the pattern is reversed and the Cadium Yellow is painted into the red.

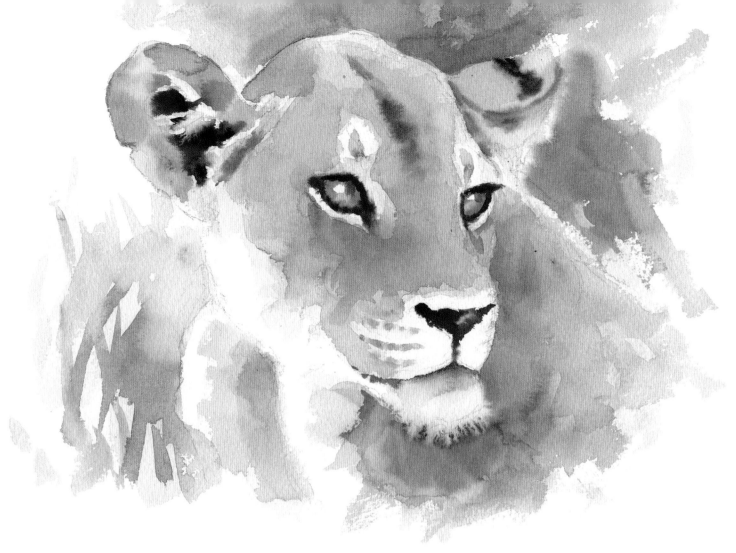

The Queen of Ngorongoro
28 x 38cm (11 x 15in)
The gentle tinting strength of
Yellow Ochre is ideal for the
warm golden undertone of this
portrait of a lioness. The colour
is perfect for the amber of the
eyes and mixes with Prussian
Blue to make the dull green of
the dry foliage.

Yellow Ochre (SO) warm

In use since prehistoric times, Yellow Ochre is a natural earth pigment, semi-opaque,
a dull yellow, earthy gold in hue, diluting to a delicious warm haze. I use it frequently
as a starting tint to bestow a warm glowing undertone and it often acts as my wetting
wash into which darker hues and tones are added. Because it is semi-opaque, the
dense pigment quickly sullies mixtures and muddies layering so I add it sparingly to
mixes. I only use concentrations in wet-into-wet applications to establish a deep
radiant gold or to lighten or push back a shade.

Low in tinting strength and natural in tone, Yellow Ochre blends beautifully
with other colours. It goes with blues to make useful dull foliage greens, works well
as a tint under blues and, especially with Ultramarine, becomes an attractive two-
colour painting combination. Mixed with Winsor Violet, Yellow Ochre becomes a
pleasing brown.

Raw Sienna (T) cool

A transparent earth colour traditionally found in clays near Siena in Italy, Raw Sienna is a similar hue to Yellow Ochre but slightly cooler, more transparent and with a lovely granulating property. Its transparency means it looks a little darker than Yellow Ochre in its concentrated form, but it dilutes to a soft, cooler yellow and so mixes well with blues to make lively natural greens; it is especially kind with Cobalt Blue.

I am often asked why I use Yellow Ochre instead of the more transparent Raw Sienna. The only answer I can think of is that the warmth of Yellow Ochre seems a natural colour for Africa and as I paint few green landscapes I have maybe not felt the need for a transparent earth yellow.

Raw Umber (T) cool

You will find Raw Umber discussed more fully in the chapter on browns, but it is also included among the yellows because its dilute form has a tint of exquisite gold. It looks so dark in its concentrated form that it often gets ignored as a yellow, but this cool, transparent, granulating pigment mixes very well with transparent blues to make natural earthy greens.

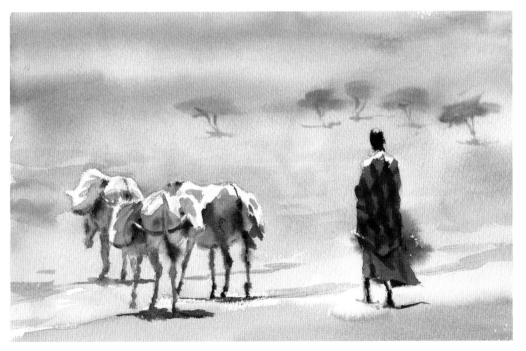

The Land Where Time Began
25.5 x 35.5cm (10 x 14in)
A wash of Raw Umber extends a golden plane of earthy yellow across the unadulterated landscape traversed by the nomadic Maasai.

Orange

Yellow mixes with red to make orange. The brightest oranges are made by mixing warm yellows with warm reds, for example Indian Yellow and Cadmium Red. Muted oranges require the blue bias from a cool yellow and a cool red, such as Aureolin and Alizarin Crimson. Bright ready-made oranges are available, but in practice I find little need for them as so much more variety can be created by mixing reds with yellows. Plenty of subjects in the natural world call for subtle oranges, especially on the African Continent, and the many shades of flesh are well matched with mixtures of warm and cool transparent yellows and reds.

Tabitha
56 x 38cm (22 x 15in)
The warm flesh tints in this unfinished portrait may not look very orange, but they are made by mixing red and yellow. Aureolin, a cool yellow, tempers the Permanent Rose, a cool red, to make glowing skin tones. Even though their bias is cool, red and yellow are still on the warm side of the spectrum and therefore ideal for the warmth of flesh.

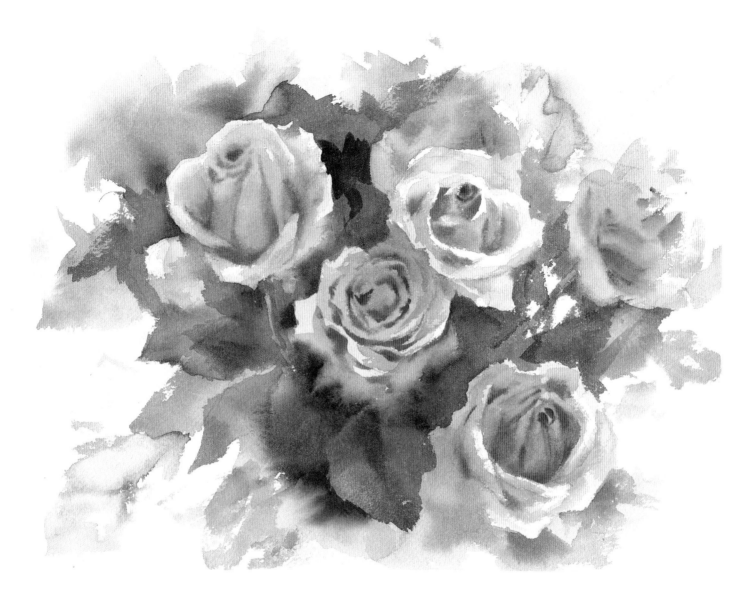

Mirrors of the Setting Sun

30.5 x 25.5cm (12 x 10in)

The radiant peachy orange of the roses is mixed from two transparent colours, Indian Yellow and Permanent Rose. The Indian Yellow was chosen for its warmth. The cool red was chosen for its radiant hue and high tinting strength, as opposed to Cadmium Red which would have been too opaque.

Playing with Yellow

Being light in tone and one of the primary colours, yellow is likely to appear in most paintings. It is often used as an undertone to set the atmosphere and temperature. In general I aim to incorporate as few different yellows as possible to ensure cohesion and very often stick to just one. However, in this painting the local colours of the subject allowed the opportunity to play with several yellows in one painting.

YELLOW OCHRE AND RAW UMBER

The warmth of Yellow Ochre and the coolness of Raw Umber are played off against each other to create depth in the painting and give a natural hue to the panniers thrown over the donkeys' backs.

CADMIUM YELLOW

The vibrant hue of opaque Cadmium Yellow is required to show off the brightness of the left-hand girl's sarong. The only other place it is used is round the neck of the other girl, but this is enough to prevent it from appearing too independent.

TRANSPARENT YELLOW

The cool Transparent Yellow over the donkey's back is needed to counterbalance the hot yellow of the sarong on the other side of the painting. The contrast exaggerates the difference in temperature bias and enlivens both yellows.

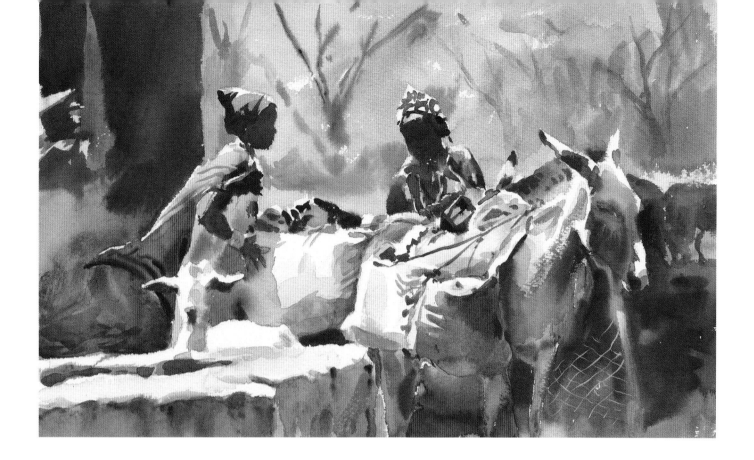

Loading the Donkeys
51 x 35.5cm (20 x 14in)
Two earth yellows convey a hot, dry African atmosphere in the background and foreground.
The cooler Raw Umber sits back behind the trees and the warmer Yellow Ochre brings
forward the sandy trough. Both colours are blended with Winsor Violet for the darker tones.

The opacity of Cadmium Yellow provides a bright, rich, dynamic yellow for the sarong.

The contrasting cool yellow of the donkey's saddle is graded in a variety of yellow tones made possible because Transparent Yellow is fully transparent and its darkest tone is nearly brown.

The preponderance of yellow in the painting throws the greys of the donkey towards mauve and the blue and red in the skirt enforce the play of temperature between the hot and cool yellows.

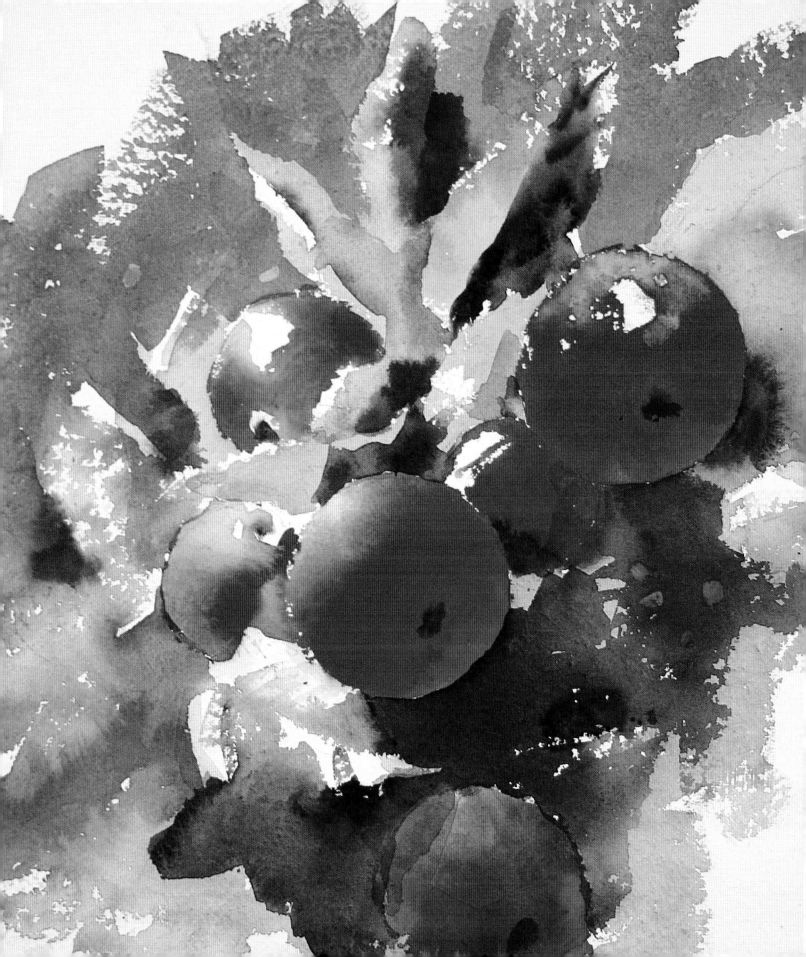

6. The Reds

Red is the colour at the warmest end of the spectrum. It is a hue that attracts attention and thus can be used to great effect in painting. Perhaps we are drawn to red because of its rarity value in the landscape – red flowers, insects, birds and sunsets are small punctuation marks in the sea of greens, blues, browns and ochres that cover the Earth.

Whatever the reason for its arresting effect, artistically speaking the attraction of red is found not only in its hue but in its inherent mid-tone; no matter how intensely you paint it, pure red cannot be dark, nor can you render it pale. In its purest form as primary red, it sits satisfyingly between the light tone of yellow and the dark tone of blue. This marriage of mid-tone and resonating hue delivers punch beside lighter or darker tones and stands out among quieter hues.

Stone Hall Orchard
30.5 x 30.5cm (12 x 12in)

SCARLET LAKE

CADMIUM
RED

Choosing a Red

Reds not only come in different hues but also differ in saturation and the way they deliver their colour: some are transparent, some opaque; some stain, some lift; some granulate; and they vary in levels of brilliance and radiance too. Red includes the obvious bright reds such as Cadmium Red, Quinacridone Red and Scarlet Lake, and also crimsons and magentas, hot browns such as Brown Madder, and the earth reds, Burnt Sienna, Light Red, Indian Red and Venetian Red.

When you are choosing a red for a specific subject, the hue is important, but the opacity or transparency of the colour will also determine whether or not it is suitable for the task: for example, a bright red sun or red rose might call for the radiance of a transparent red, while a red car or checked cloth might demand the brilliance of an opaque. The heavier particles of opaque red have more power in a wet-into-wet blend than a lighterweight transparent red, so how far and fast you want the colour to spread into a wash might also be a consideration.

BROWN
MADDER

ALIZARIN
CRIMSON

QUINACRIDONE
RED

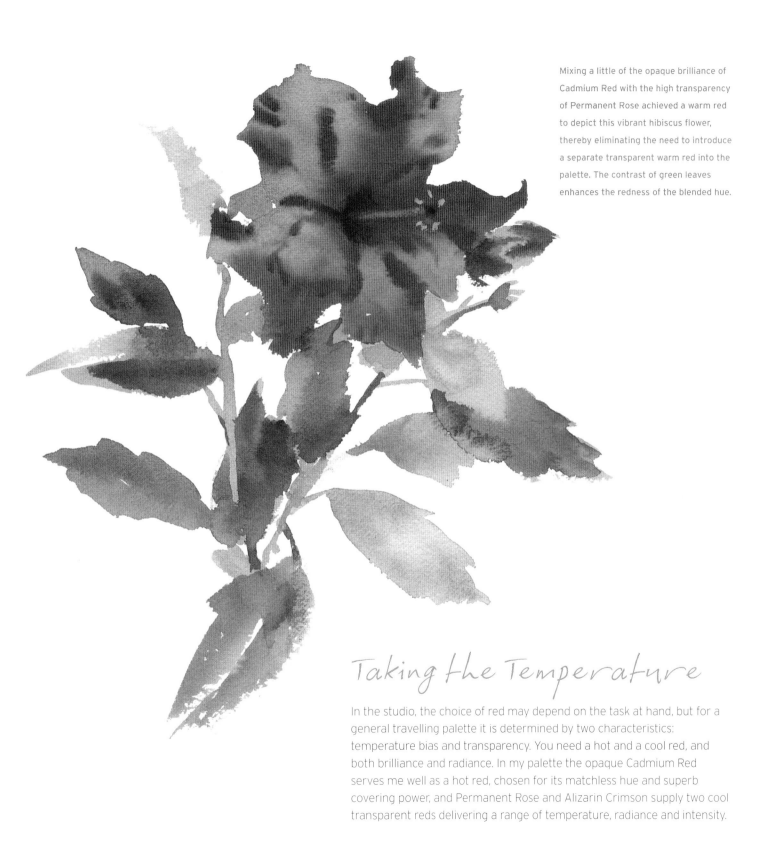

Mixing a little of the opaque brilliance of Cadmium Red with the high transparency of Permanent Rose achieved a warm red to depict this vibrant hibiscus flower, thereby eliminating the need to introduce a separate transparent warm red into the palette. The contrast of green leaves enhances the redness of the blended hue.

Taking the Temperature

In the studio, the choice of red may depend on the task at hand, but for a general travelling palette it is determined by two characteristics: temperature bias and transparency. You need a hot and a cool red, and both brilliance and radiance. In my palette the opaque Cadmium Red serves me well as a hot red, chosen for its matchless hue and superb covering power, and Permanent Rose and Alizarin Crimson supply two cool transparent reds delivering a range of temperature, radiance and intensity.

Mixing with Red

Endangered

Endangered

20.5 x 28cm (8 x 11in)

Permanent Rose pervades all the mauve, orange, dark green and brown mixes in this watercolour. Ultramarine (Green Shade) and Yellow Ochre are the other two contributors to the palette.

Red mixes with yellow to make orange and with blue to make violet. When red is mixed with green, its opposite on the colour wheel, they cancel each other out and produce greys, browns and blacks. Thus you can mute a garish red, or green, just by glazing with the opposite colour, or make colourful greys and browns by blending the two hues on the paper or mixing them in the palette. To make deep, vibrant blacks I often mix Prussian Blue, a cool blue, with Cadmium Red, a hot red, or use them in a two-coloured painting to create an exciting contrast of temperature and tone.

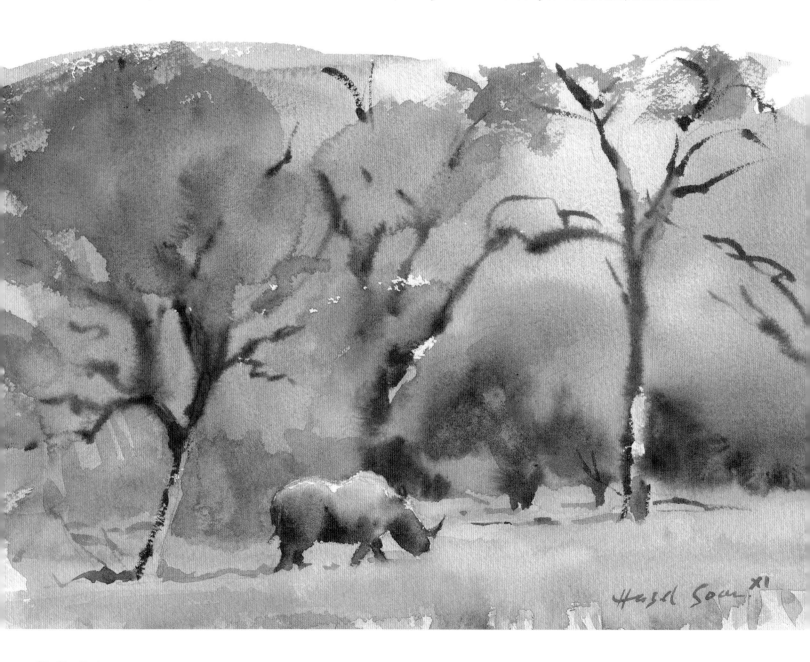

Opposites Attract

Resonance between colours is increased by contrast, so reds appear brighter when set alongside greens and blue-greens. The hotter the red (the more it veers to orange) and the cooler the green (veering to blue) the more vibrant the contrast, so for the greatest effect, pitch a turquoise against a hot red of the same tone. When two opposite colours are identical in tone they create an optical vibration because the eye cannot work out which one is in front.

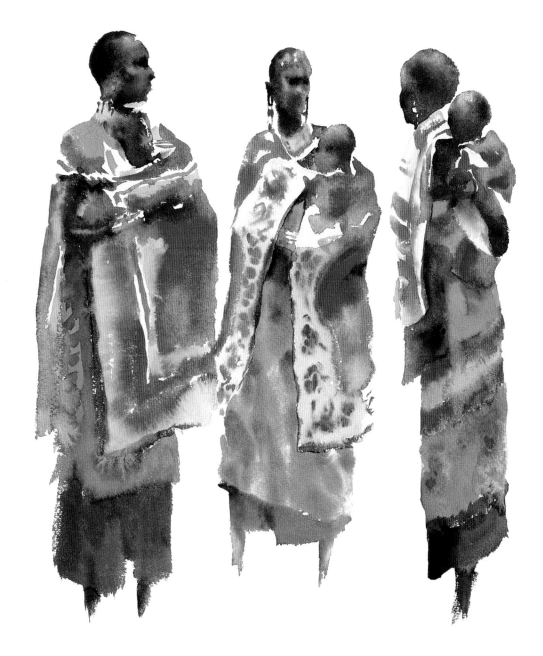

Mother Africa

76 x 51cm (30 x 22in)

Here, the transparent reds of Quinacridone Red (left) and Permanent Rose (middle) are used for the radiant fabrics, while on the right – where smaller areas of red are required to stand out against turquoise – Cadmium Red is used to boost the contrast with its opaque strength.

Cadmium Red (O) hot

A brilliant opaque red extracted from heavy metal, Cadmium Red is a traditional pigment so intense in hue that very little goes a long way. It has great covering power, which means it can obliterate a colour beneath it and overcome a colour in wet-in-wet blending.

In most watercolour brands Cadmium Red is the closest pigment to primary red and is therefore the brightest red in the palette – but be careful, as the opacity and intensity of this thrilling and powerful colour quickly dulls mixes. However, do not be afraid to exploit the brilliance of Cadmium Red in dense, rich washes; its brightness is lost in dilute tints and it becomes lacklustre. It has slight granulating and staining properties.

Light Red (SO) warm

The only other opaque red in my palette is Light Red. The name is misleading, since it looks more brown in the palette, but it is the lightest of the red earths (see page 79). This warm, semi-opaque red covers quickly and makes resonant skin tones. I use it for fair skins darkened by shadow and especially for the faces and limbs of figures in a landscape or urban setting.

Falling Asleep
30.5 x 40.5cm (12 x 16in)
The warm skin tones and the sarong of this sleeping girl are painted with Light Red, tinted with Indian Yellow, Yellow Ochre and a touch of Ultramarine. Because Light Red is opaque, the brushstrokes are applied in single washes to prevent loss of transparency.

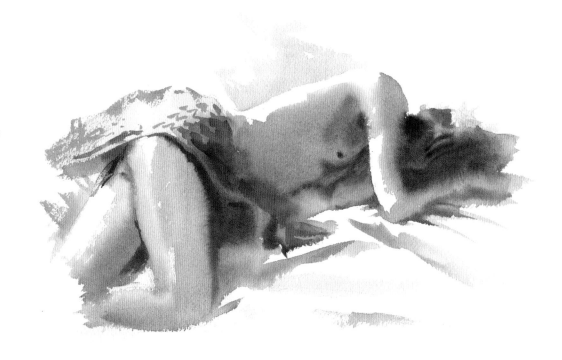

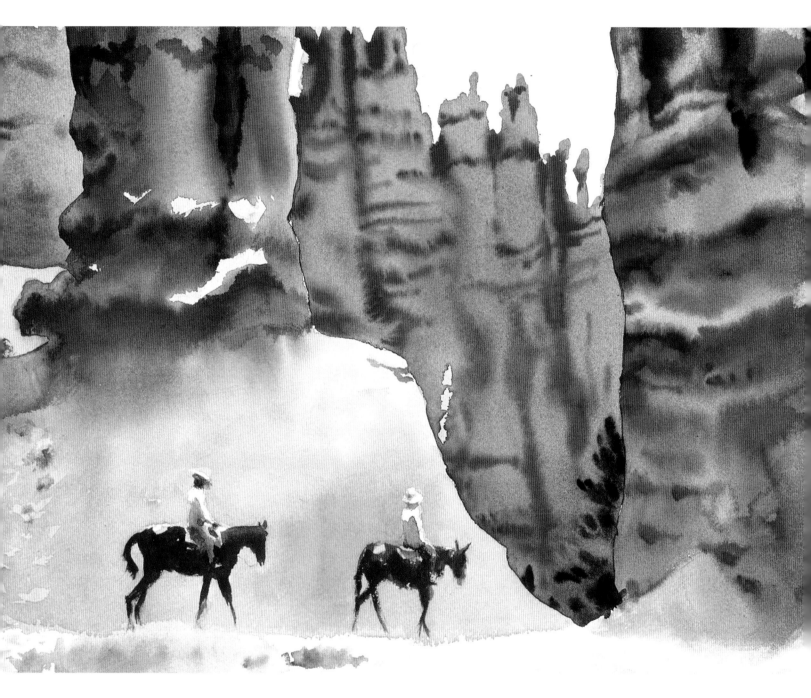

Red Trail

30.5 x 40.5cm (12 x 16in)

Broad washes of Permanent Rose mixed occasionally with Indian Yellow depict the legendary red sandstone pillars towering above Bryce Canyon in Utah. To show the fissures in the rock, linear strokes of slow-spreading Cadmium Red were dropped into the wet wash, heightening the colouring.

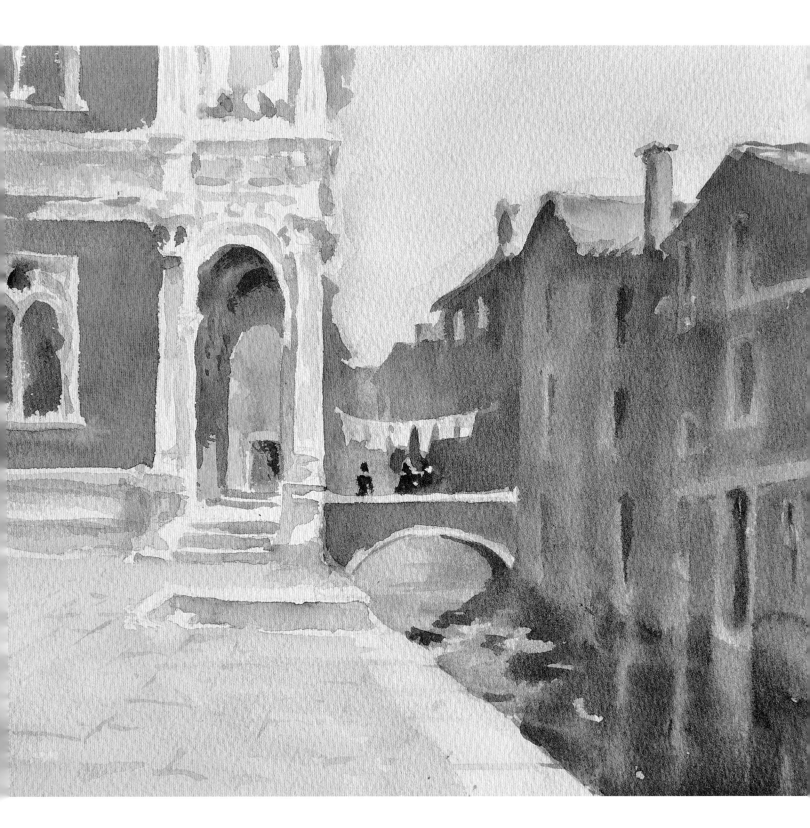

Passages of Time
30.5 x 35.5cm (12 x 14in)
The stunning hue of transparent
Quinacridone Red brings a warm
glow to the lit walls of the Church of
San Rocco. Mixed with Burnt Umber,
it makes the shaded reds of the
buildings on the opposite side of
this Venetian canal.

Quinacridone Red (T) warm

This very transparent carbon colour is pinker than Cadmium Red
and feels deliciously velvety when mixed on the palette. Its tinting
strength does not seem to be as high as the cooler reds, so a lot of
pigment is needed. The brightest and warmest of the transparent
reds, it supplies the radiance of bright red in pale washes, the point
at which the redness of Cadmium Red falters. Its concentrated form
is not dark; its potency lies in its range of radiant tints.

Scarlet Lake (ST) warm

The semi-transparent Scarlet Lake is a glorious warm red veering to yellow.
Traditionally made from vermilion and cochineal, today it is made synthetically
from carbon. Its bright red hue stays vibrant in dilute tints, but its disadvantage is
that the highly staining colour taints the enamel palette.

I painted the shape of the elephant with a
wash of Yellow Ochre, added Scarlet Lake wet-
into-wet and then touched in Cobalt Blue for
the darkest tones. This blend of mildly opaque
colours has produced hushed pastel hues.

Permanent Rose (T) cool

A cool red is one that veers toward blue and Permanent Rose is one of many transparent crimsons available among the carbon colours. It is a glorious pink pigment that is dark enough in its concentrated form to make impressive purples yet dilutes to the palest radiant pink. In the absence of a bright transparent red it can be mixed with Indian Yellow or Cadmium Red to simulate a radiant primary red hue. It is one of my most favoured colours in a three-colour palette alongside Prussian blue and either a transparent yellow or Yellow Ochre.

Alizarin Crimson (T) cool

Because it is so dark in its concentrated form, it is hard to believe that Alizarin Crimson can dilute to such a gentle pink and then be turned to a red by mixing with yellow. A potent and versatile cool red, it was created with carbon chemistry in Germany in the 19th century and has been beloved by artists ever since for its high transparency and strong tinting strength. With such a broad tonal range, it contributes well to blacks and purples. It is good for painting reds cast in shadow, where it is often better to select a darker red than add darkness to an existing hue.

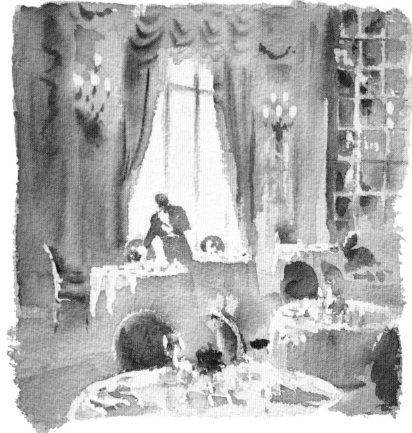

Romantic Setting
15 x 15in (6 x 6 in)
In this three-colour sketch of the Dining Room at the Ritz, London, Alizarin Crimson supplies the dark red shades, the pale pinks and, mixed with Yellow Ochre, the reds. Mixed with Prussian Blue, it creates the grey of the uniform.

The Girl with a Pearl Earring
76 x 56cm (30 x 22in)
The radiant glow of pure Permanent Rose is visible here under the eyebrow, nose, lips, hair and chin, and in the sarong. It was the first colour laid in this portrait and serves as a warm undertone beneath the cooler violets and browns.

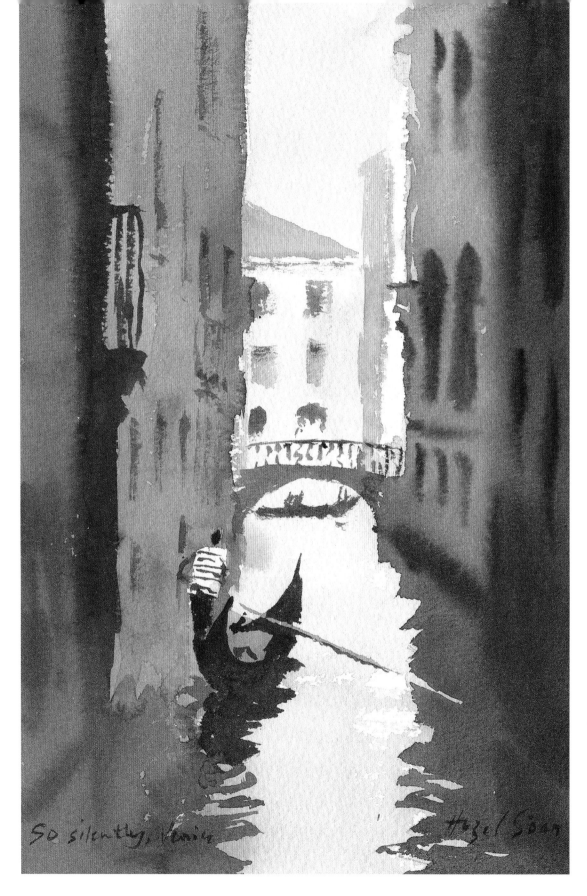

So silently, Venice

Hazel Soan

Go Silently
28 x 20.5cm (11x 8in)
Many of the
predominantly red
buildings for which
Venice is so famous are
red-browns. Burnt Sienna
and Brown Madder are
blended in this painting
to bring a radiant hue to
a sunlit wall.

Red Earth Colours

Traditional pigments derived from natural burnt ochres, the red earth colours are frequently found in areas of volcanic activity because ochre reddens as it is heated. In the current Winsor & Newton range, Light Red is still made from natural iron oxide but Indian Red, Venetian Red and Caput Mortuum Violet are all made from synthetic iron oxide. They are rich, opaque, dense colours, some with slight granulating properties, the least opaque being Light Red. While they offer rich, positive colours, they will muddy a mix if used carelessly.

Browns as Reds

Discussed more fully among the browns (see page 122), Burnt Sienna, also a red earth colour, and Brown Madder, an organic pigment, are two very desirable and useful transparent red-brown pigments. For the reds of the earth, buildings, the animal kingdom and hot landscapes such as those found in Africa, they make satisfying 'reds' when they serve as the warmest colour in the palette.

It is fitting that Light Red, an earth colour, should describe the red of an elephant coated in Kenyan soil. For the shadows it is blended with Ultramarine (Green Shade).

Kilimanjaro Rising from the Dust
20.5 x 28cm (8 x 11in)
Three semi-opaque colours, Light Red, Cobalt Blue and Yellow Ochre, breathe a gentle dusty distance into this atmospheric sketch of Kilimanjaro.

Violet

Mixing red with blue produces the secondary colour violet. The cleanest, most vibrant violets come from cool reds and warm blues (for example Permanent Rose and Ultramarine or Opera Rose and Cobalt Blue). Transparent pigments make the deepest violets, while opaque colours make the mauves and lilacs. Restrained purples, browns and even blacks can be created with warm reds mixed with blue.

Winsor Violet (Dioxazine) (T) warm

The one ready-made violet I use frequently is Winsor Violet (Dioxazine), which is deep in tone, highly transparent and staining, and dilutes to a lovely pale mauve. Mixed with Burnt Sienna and other transparent browns and blues, it reaches vibrant depths of tone. With Burnt Umber and Ultramarine, or Prussian Blue, it makes rich, dark browns and as a glaze it can liven up a dull black.

Winsor Violet is a warm colour veering to red but easily cooled towards blue; the temperature is very influenced by the colours beside it, so it is exceedingly versatile in mixes. Mixed with Sap Green, it makes an instant dark translucent green for the hidden depths in foliage or flower paintings.

Violet blends happily with yellow, its opposite in colour and tone, and usefully creates mid-tones where the two colours meet and mingle. It combines well with warm yellows to make honey browns.

Blur in the Bush
20 x 20cm (8 x 8in)
In this sketch, the Yellow Ochre provides the light tones and the Winsor Violet the dark. Where they meet, they create the mid-tones and so suggest the rounded form of the elephant's torso. Mixed, they make a light brown for the dry leaves.

Small and Smaller

30.5 x 30.5cm (12 x 12in)

Most of the violets in my elephant paintings are reached by mixing blue with
red. Here, two young elephants dashing ahead of the herd are painted first
with a tint of Yellow Ochre, and then Alizarin Crimson and Ultramarine (Green
Shade) are applied in wet-into-wet washes. The deepest darks are mixed in the
palette from the same three colours.

Playing with Red

Red is a progressive colour, which means it comes forward in the picture rather than recedes. Consequently, it can be used to attract attention and draw the eye to a focal point. As the main colour for a painting it evokes a positive emotional response, cheerful and buoyant; whether you are painting with it or just looking at it, this warm, optimistic and extrovert hue can lift the spirits dramatically.

CADMIUM RED

As the inner depths of the poppy petals are deep in hue, a brilliant red is required, for which opaque Cadmium Red is perfect. The dense particles spread slowly, so it is not difficult to keep the intense pigment close to the centre of the flower in the wet-into-wet blends.

QUINACRIDONE RED

While it is radiant and warm, and velvety in mixing, Quinacridone Red does not have the saturation of Permanent Rose. It blends quickly when laid beside wet colour but as it is mid-tone it cannot deepen or darken a mix, so its influence is gentle. It is ideal, then, for the translucent reds at the tips of the petals that must blend readily with the deeper Cadmium Red in the centre.

PERMANENT ROSE

The cool transparent pink of Permanent Rose mixed with the Cadmium Red makes it more radiant and cools the hot, positive red to suggest the length along the petals towards the fringed tips. Its lightest hue is perfect for the pale pink while its darkest hue is warm magenta, so mixed with the cold of Prussian Blue it can make the violet required in the centre of the poppy.

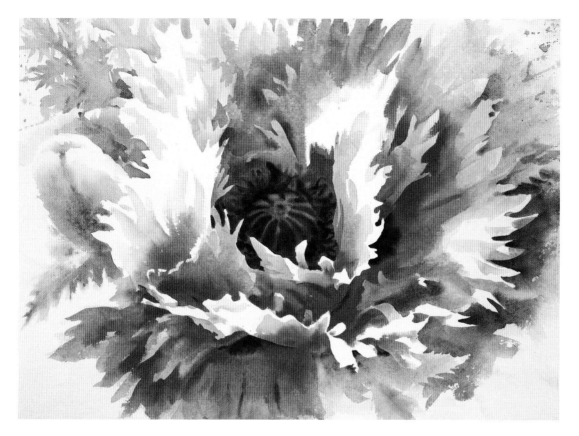

With an Eye on the Sun
56 x 76cm (22 x 30in)
The petals of the poppy are full of life and their hue is both bright in colour and radiant in translucency. To achieve this in paint you need to combine the two properties offered by opaque and transparent pigments – brilliance and radiance. Use the power of contrast in hue and tone and create variety in shape and brushmarks.

By blending an opaque colour into a transparent colour of similar hue, both brilliance and radiance can be achieved in the same passage of colour. Here, Cadmium Red is brushed into wet washes of both Permanent Rose and Quinacridone Red to create the striking colour at the heart of the poppy and yet maintain the translucence of the petal.

Turning the red to orange with a dash of Indian Yellow brings out, by contrast of hue, the pink of the Permanent Rose and the red of the Quinacridone Red. By showing a range of red from orange to magenta, the redness of the flower is subtly enhanced.

The use of opposite colours maximizes their impact. Here, Prussian Blue and a green made from Indian Yellow and Prussian Blue are brought up against the reds to create contrast.

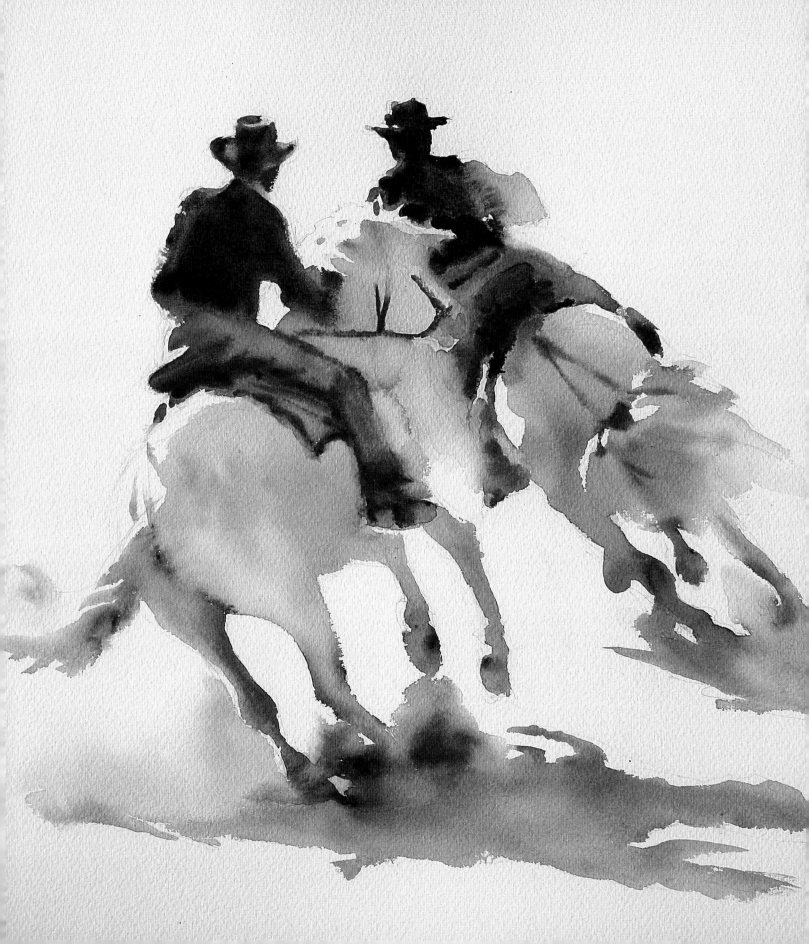

7. The Blues

There is barely a painting in this book that does not contain some blue. Of the three primary colours, it covers the widest tonal range from a pale dilute tint to a deep, intense dark, making it ideal for monochromatic paintings. Frequently found in shadows, the sky and the sea, essential in the making of blacks and often used to mix greens, this hue is employed in greater quantities than any other colour in the palette.

Blues sit at the cool end of the spectrum, warming up as they lean towards violet or cooling down as they shift towards green, the opposite of red. Psychologically blue is a more peaceful colour than either red or yellow; it is calming and inviting and even in its darkest form it is not disturbing.

Arena
56 x 56cm (22 x 22in)

Choosing Blues

Such a versatile colour has many permutations – the key to which blues to include in your palette is based on the need for transparency and a choice of temperature bias – you need both a warm and a cool transparent blue. Blue is usually the first colour I select when planning a painting and the decision between warm or cool blue determines which yellow and red I use for making the secondary and tertiary hues, especially the greens. In my usual palette, Ultramarine (Green Shade) is the warm transparent blue and Prussian Blue is the cool one.

Alongside these, Indigo, a dark opaque blue, is very useful for arriving at deep darks quickly. Semi-transparent and semi-opaque blues such as Cobalt Blue and Cerulean should also be included, since their bright hues, low tinting strength, covering power and granulating properties are very valuable and attractive in a watercolour.

Choosing and staying with one blue throughout a painting ensures harmony, especially as it can be carried through from the lightest to darkest tones.

INDIGO

PRUSSIAN
BLUE

COBALT BLUE

CERULEAN

ULTRAMARINE
(GREEN SHADE)

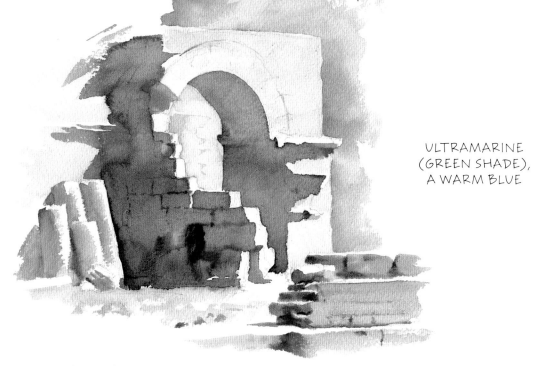

ULTRAMARINE
(GREEN SHADE),
A WARM BLUE

Blue for Shadow

Transparent blues make lively shadows. When the sun is at its height or the air is devoid of moisture, shadows may seem very dark, but if the sun is at an angle and there is moisture in the air they generally lean to blues and violets and are tinged with reflected colour from an adjacent object. The transparency of watercolour enables shadows to be laid as glazes on top of other colours or painted first to fix them in place at the start of painting, thereby establishing them before they change with the angle of the sun or disappear altogether if the sky becomes overcast.

Shadows belong to the object that casts them – they are an integral part of it and should not be treated as a separate feature, so link the blue into the object or continue the colour of the object into the shadow.

The different temperature bias created by mixing with a warm or a cool blue is clearly visible in these two sketches at the Théâtre Antique in Arles.

PRUSSIAN BLUE,
A COOL BLUE

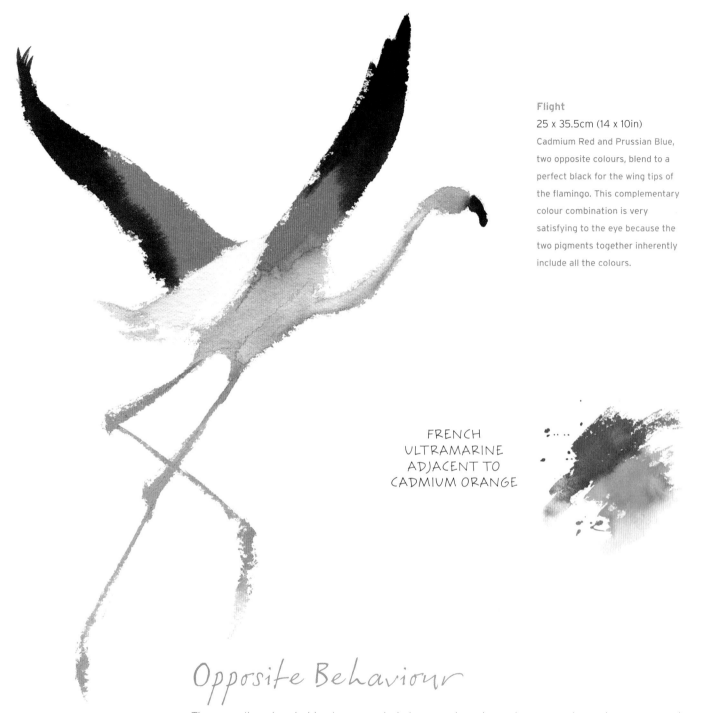

25 x 35.5cm (14 x 10in)
Cadmium Red and Prussian Blue,
two opposite colours, blend to a
perfect black for the wing tips of
the flamingo. This complementary
colour combination is very
satisfying to the eye because the
two pigments together inherently
include all the colours.

FRENCH
ULTRAMARINE
ADJACENT TO
CADMIUM ORANGE

Opposite Behaviour

The opposite colour to blue is orange, but since most ready-made orange pigments are opaque to some degree, mixing them with transparent blue results in browns and violets rather than black. However, if you mix Ultramarine with Burnt Sienna, a transparent brown that is slightly orange, you will make a pleasing black and excellent neutral greys. In large dark washes this complementary combination can neutralize the hues and appear dull, so other browns such as Burnt Umber or Raw Umber can be used instead to create livelier darks. The cooler blues, such as Prussian Blue, will mix beautifully with all these browns to make resonant dark green shades ideal for foliage. Prussian Blue finds its opposite in Cadmium Red and mixes to a marvellous black.

Thirsty and Hungry
28 x 35.5cm (11 x 14in)
Here, the tawny hides and shaded bellies of the lionesses
are painted with Ultramarine and Burnt Sienna but the
two colours are added separately wet-into-wet and
allowed to blend on the paper. As they mingle, each
pigment keeps its hue and does not turn to grey.

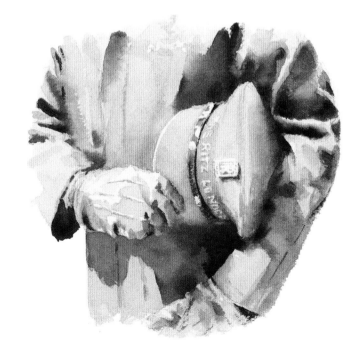

Blues can be deepened and warmed
with violet. In this sketch of the
chauffeur's uniform, Winsor Violet is
added to Ultramarine. Burnt Umber
is introduced to create the darkest
tones and added to the blue to make
the cooler tint of the gloves.

Warm Transparent Blue

A warm blue veers in the direction of red on the colour wheel and so mixes with cool reds, crimsons and pinks to make the brightest violets, mauves and purples. The leaning to red also means that a warm blue mixes with yellow or brown to make attractive dull and subtle greens.

Ultramarine (Green Shade) and French Ultramarine..... (T) warm

Ultramarine was traditionally made from ground lapis lazuli, a semi-precious stone found in Afghanistan. It came in 'green shade' and 'red shade' and was so expensive that Renaissance painters deemed it worthy of being the colour for the Virgin Mary's robe. In 1824 a European competition was launched to find a synthetic version of the same hue which would cost much less; the prize was won by the French chemist Jean-Baptiste Guimet, and the blue was consequently named French Ultramarine.

In the Winsor & Newton range there is both a French Ultramarine and an Ultramarine (Green Shade) to reflect the twinned shades of the original lapis pigment. Although both ultramarines are the same hue, made from the same inorganic pigment, and are both lifting colours, they behave slightly differently in mixing and on paper. Ultramarine (Green Shade) is more intense and almost shimmers, while French Ultramarine, the red shade, has an attractive and useful granulating quality.

Ultramarine is a very kind blue because it lifts readily, especially in the case of French Ultramarine, which allows for easy lightening of tones and softening of edges – though you must take care not to shift the pigment by mistake. The perfect blue for warm shadows and for white in shade, it mixes easily to a grey or black with the earth colours Burnt Sienna and Burnt Umber.

Beach Girl
18 x 20.5cm (7 x 8in)
The granulation of French Ultramarine gives a pleasing mottled effect to the washes in this sketch of a girl on the beach.

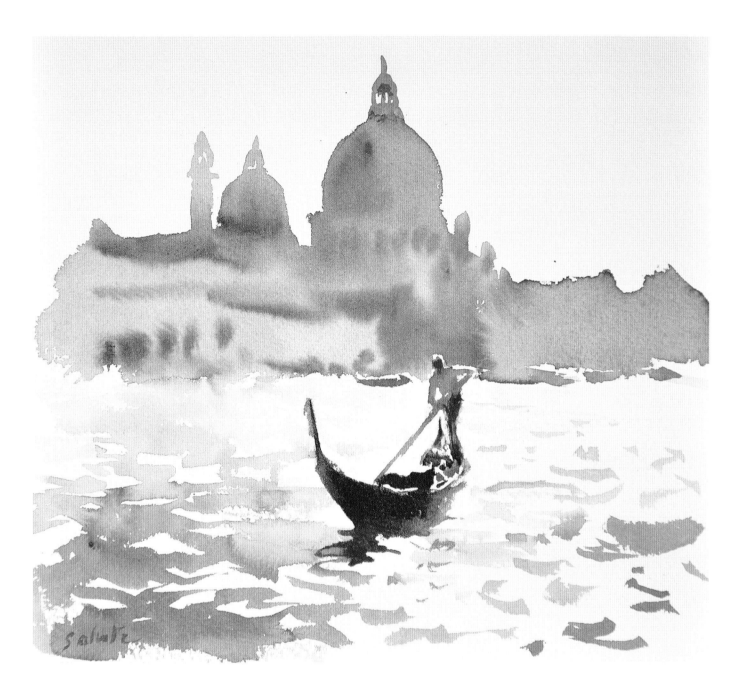

Sapphire Lagoon

28 x 25.5cm (11 x 10in)

For this painting I used Ultramarine (Green Shade), a warm, transparent blue. A dash of Cadmium

Red is touched into the gondolier's face and buildings and a little indigo darkens the gondola.

Cool Blues

Cool blues veer towards green and thus mix with yellow to make vibrant greens. With cool reds such as Alizarin Crimson or Permanent Rose, they make deep understated purples. As blue is the coolest colour in the spectrum there are many cool blues to choose from.

Prussian Blue (T) cool

Some artists avoid Prussian Blue because it is very intense and can be fierce, but it has a wonderful tonal range, from very pale to the deepest dark. It was made by a German colourmaker in 1704, in error - his aim was to make red but he was low on supplies of potash and, using a batch distilled with animal oil, ended up with blue instead. Thus Prussian Blue became the first chemically synthesized colour. It has a unique quality in that it fades in light and recolours in the darkness.

The Open Road, Mount Carmel Highway
28 x 40.5cm (11 x 16in)
Prussian Blue pervades all areas of this painting. As a pale tint in the sky it is tinged with Indian Yellow, in the mountains it is tinted with Permanent Rose and in the scrubby foliage they all mix to dull the greens in the shadows of dawn.

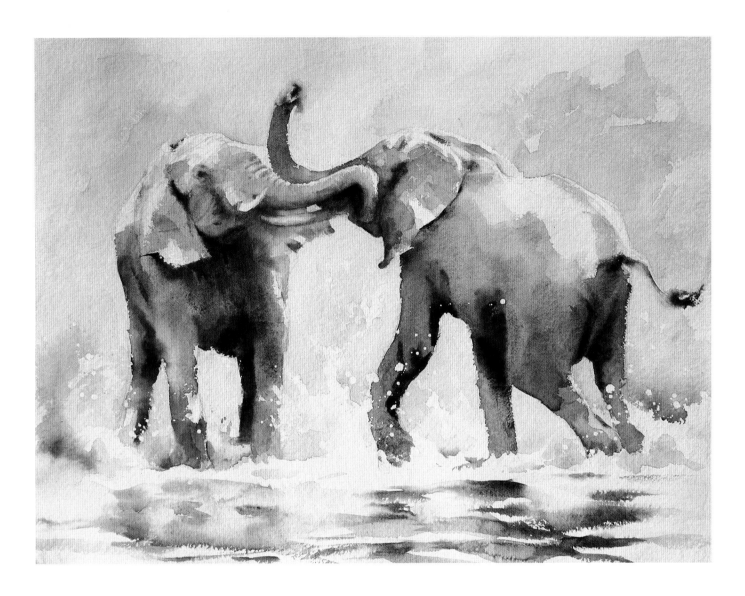

With its high tinting strength, Prussian Blue can be used sparingly, so a tube or pan lasts a long time. It is a staining colour so once laid it cannot be removed, making it very stable under subsequent tints and washes. Highly diluted, it is perfect for whites that are barely in shadow.

Prussian Blue mixed with yellows makes attractive, lively greens. Because it is so transparent, it maintains its translucency through several diluted layers of application, though in its intense form it is almost a black.

A Bigger Splash
56 x 76cm (22 x 30in)

Yellow Ochre and Prussian Blue are deepened, wet-into-wet, with Raw Umber, Burnt Umber and Windsor Violet to create this dynamic clash on the rough Khadi paper. Winsor Violet acts as the 'red', the warmest colour in this otherwise cool painting controlled by the wide range of tones offered by Prussian Blue.

Winsor Blue (T) cool

When Prussian Blue was too cold for the skies and shadows of the red landscapes of Utah, I turned to Winsor Blue for a more gentle version of a cool transparent blue. This comes in Green Shade or Red Shade and is equivalent to Phthalo Blue or Monestral Blue in other ranges. A lovely blue, it is less fierce and cold than Prussian but also has great tinting strength. It mixes with other colours to make charming radiant hues and is one of the trio of primaries suggested by Winsor & Newton for creating the greatest range of colour and tone in a limited three-colour palette, the others being Permanent Rose and Winsor Lemon.

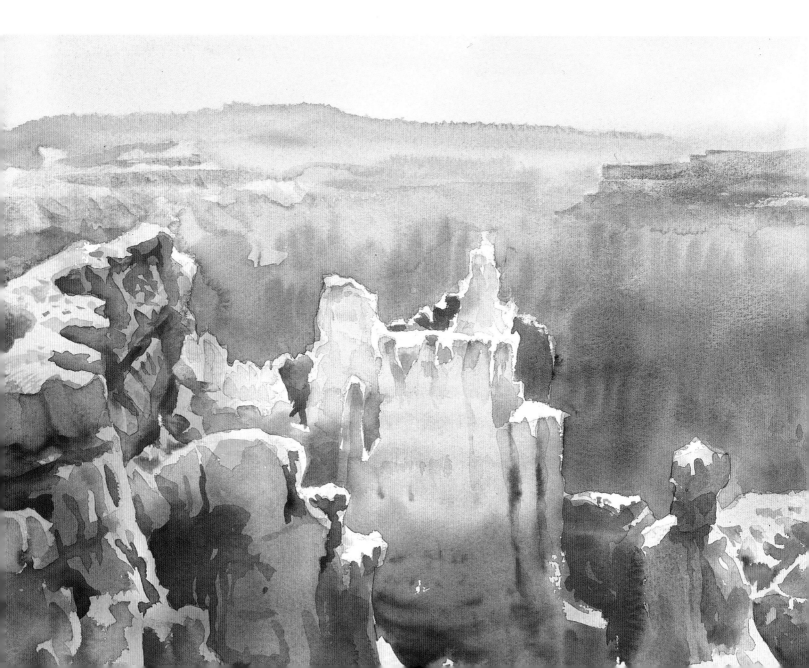

The Power and the Glory

45.5 x 101.5cm (18 x 40in)

Indanthrene Blue can be seen in its pure form on the silks of the left-hand jockey. This delicious dark blue mixes perfectly with the other three colours, Brown Madder, Quinacridone Gold and Permanent Rose, to make the variety of rich browns for the different horses' hides. Mixed with the latter colour, it provides the lilac which you see in the shadows on the white horse.

Castles in the Air

30.5 x 40.5cm (12 x 16in)

In Bryce Canyon, Utah, Winsor Blue (Green Shade) mirrored the shadows on the bleached rock in the central stack. I painted the same dilute tint everywhere except the white highlights and allowed it to dry, then laid glazes of Cadmium Red, Quinacridone Red and Permanent Rose on top to emulate the extraordinary colours of the sandstone at Bryce Canyon.

Indanthrene Blue (T) cool

A carbon blue standing between Prussian and Ultramarine in both hue and tone, Indanthrene Blue is dark in its concentrated form and highly transparent, mixing to a perfect black when added to transparent reds and yellows such as Quinacridone Red and Quinacridone Gold. It is a pleasing colour, en route to Indigo, but is less vibrant than Prussian and Ultramarine and therefore possibly superfluous to a general palette. I use it on large pieces where I need to reach dark colours quickly or want both a cool blue and a warm dark brown.

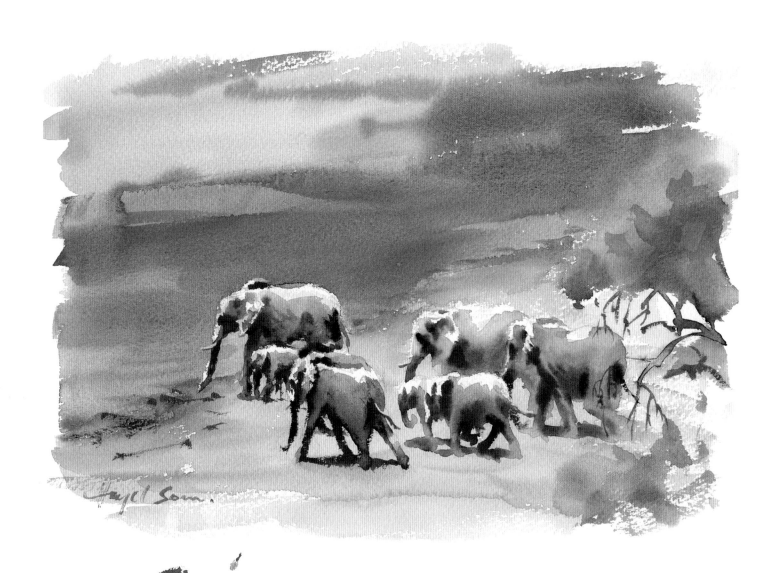

Cobalt Blue (ST) warm

A semi-transparent granulating pigment derived from cobalt and discovered in 1802, Cobalt Blue is less dark than the fully transparent blues. Although expensive, its bright hue and hint of opacity are unmatched in any palette and it is appreciated also for its low tinting strength. It is close to a primary blue, but because the pigment is slightly opaque it cannot mix with red and yellow to reach a black, instead making a delicious soft grey.

The opacity makes this a subtle and gentle blue, lovely for clear sunny skies, where a single layer maximizes the transparency and enhances its granulating properties. It affords a misty quality when mixed with other colours, and being gentle, it can indicate limpid shadows on white subjects. Mixed with Raw Sienna it makes practical greens, with Burnt Umber it makes a lively dark, and with a cool red such as Permanent Rose it creates stunning lilacs and mauves.

Because it is bright and appears in most ready-made palettes it is often ill-advisedly mixed with opaque yellows for bright greens, which can result in the dreaded 'mud'.

Beware of the Crocodiles
30.5 x 40.5cm (12 x 16in)
The soft warmth of Cobalt Blue is chosen to reflect the bright blue sky in the river and marry with Permanent Rose and Indian Yellow to make the warm mauves and greys of the elephant hides. Being slightly opaque, the blue recedes into the valley.

Cerulean Blue (SO) cool

The opaque blues on the cool green side of the spectrum range from sky blues to tropical sea greens. They are bright granulating colours. Cerulean Blue, also made from cobalt, is a mid-tone pale blue, variously opaque, a delightful granulating pigment which can deliver a flat wash. Veering towards green, it lends itself well to painting turquoise, but greens made with this blue tend to be rather opaque and garish so are best avoided unless you want a manufactured or vivid flat hue.

Cerulean Blue has excellent covering power so it can be used in its concentrated form to restore shaded white details (a balustrade, for example) or cool highlights on foliage and to add blue patterns on fabrics. It mixes well with Permanent Rose to make mauve.

Manganese Blue is more turquoise and slightly more transparent than Cerulean.

Charlie
76 x 30.5cm (30 x 12in)
Cerulean Blue mixed with Permanent Rose and Yellow Ochre casts an attractive granulating texture over the running figure as the heavy pigment particles settle in the troughs of the rough Khadi paper.

**Where the Sea meets
the Land**
56 x 66cm (22 x 26in)
The swill of the tide as it
ebbs and flows over white
sand is painted with
Cobalt Turquoise and
touches of Aureolin. A
dusting of Cobalt
Turquoise is washed over
the rocks to marry the
two halves of the painting.

Cobalt Turquoise (O) cool

This is a ravishing milky turquoise, a blue veering to green (or perhaps a green
veering to blue). Opaque and granulating, it is best kept to a single layer to show
off its tropical beauty. Use it pure and diluted in small accents under darker
natural greens to express the sheen of cool light within foliage.

Indigo (O) cold

The need for a really dark covering blue in the palette is answered by Indigo, an intensely dark, cool hue. It used to be a natural pigment derived from the indigo plant but it is now made synthetically and is a lot more lightfast. Being so close to black, it is necessarily opaque in its concentrated form, but it dilutes to a pleasing grey-blue in the Winsor & Newton range and works well in monochrome paintings as it can incorporate the whole range of tones.

Indigo is a staining colour, but if it is laid in its darkest form you can usually lift off surplus pigment to lighten the tone. Mixed together with Sepia, a cold opaque brown, indigo makes a vibrant black ideal for strong silhouettes. One layer provides the best resonance as the colour is so dark. Be careful not to allow a colour as cold and opaque as this to contaminate any other colours in your palette.

Indigo is so dark a blue it looks black. Dropped into a pale tint of Prussian Blue, it spreads out sedately to render perfectly the feathered plumage of the ostrich.

Glittering Past
30.5 x 40.5cm (12 x 16in)
The wide tonal range offered by Indigo enables this backlit view of a gondolier plying the Grand Canal in Venice to be painted with one colour, with the exception of a dash or two of Cadmium Red.

Painting Sky and Sea

No chapter on blue could be complete without discussing the painting of the sky and the sea, since their predominant colouring is often blue. Water acts as a mirror for the sky, so when you paint a sky wash you need to continue or repeat the hues in the reflective surface below.

Feathered clouds
The paper is wetted all over. A gentle tint of Indian Yellow imparts a glow above the horizon. Ultramarine (green shade) is brushed from the top right, leaving areas untouched for the soft white feathery clouds and allowing the blue to waft gently into place.

Blue Skies

The exact blue of the sky is not as important as the coherence of the painting, so choose your blue to suit the rest of the colour scheme or for the need to lift or stain. Look for the temperature bias you need, cool or warm.

The maxim 'less is more' definitely applies when creating atmospheric sky washes. Wetting the paper helps to hold a large sky together and prevent seams. When applying colour, start at the top so that as you approach the horizon the offloading of pigment from the brush echoes the gradual lightening of tone in the sky.

Pay close attention to tone: skies are usually paler than the landscape and are in the distance, so may not benefit from being too strong or too busy. Cool temperature bias and opacity help pale tints retreat. If the sky is the first wash painted, plan for the landscape below and if some area in the foreground is lighter than the sky, allow for this by leaving it untouched by the wash (see below left).

In most cases, once the sky is painted, it will need to dry before you can continue. If time is short or the atmosphere humid, consider whether the sky needs painting first or indeed at all – if it is light it could be left as white paper or later tinted with a glaze.

Cumulus clouds and thinking ahead to the foreground
The paper is wetted nearly all over but stops short to account for the rounded rock forms in the foreground (which on the lit side will be lighter than the sky) and is dabbed dry at top right to enable crisp edges to the tops of the voluptuous white clouds. Yellow Ochre tints the lower clouds before the Ultramarine is brushed into place.

The Blue of the Sea

Although the sea is often seen as blue, that is largely because it is reflecting the colour of the sky. In general, all you need do to suggest a wet surface is to tint the area with the tone and colour of the sky or feature above. Sometimes, however, the sea appears to be a completely different hue to the sky, in which case you need to bring cohesion to the painting by introducing the sky colour somewhere in the water.

Large masses of moving water benefit from flecks of untouched white paper left within the wash, and ripples are often best indicated by linear streaks of untouched paper. You will find masking fluid, wax resist and scratching off useful allies here. Once again, less is more; the less overworked the water, the fresher it will feel. To suggest reflections, either touch the colour into the wash while it is wet or let it dry and then rewet it before brushing in colour. A reflection is positioned directly below that which it reflects, but it need not be highly accurate in length or shape to be convincing.

Neptune's Lace
35.5 x 28cm (14 x 11in)
The blue sky and ocean background are painted with Ultramarine. The green breaking waves are painted with Viridian. To forge the link, Viridian is laid in a tint over the distant sea and the blue is brought into the foreground.

Playing with Blue

As you have seen, blue is the most versatile hue because it runs through the whole tonal range; in its palest form it can tint the shadows in the lightest of hues and in its darkest form it can contribute to the darkest of blacks. The lifting nature of Ultramarine in particular makes it a safer blue to use than its cooler counterparts, several of which are strong staining colours, and its warmth at the cool fringe of the spectrum makes it a very pleasing hue.

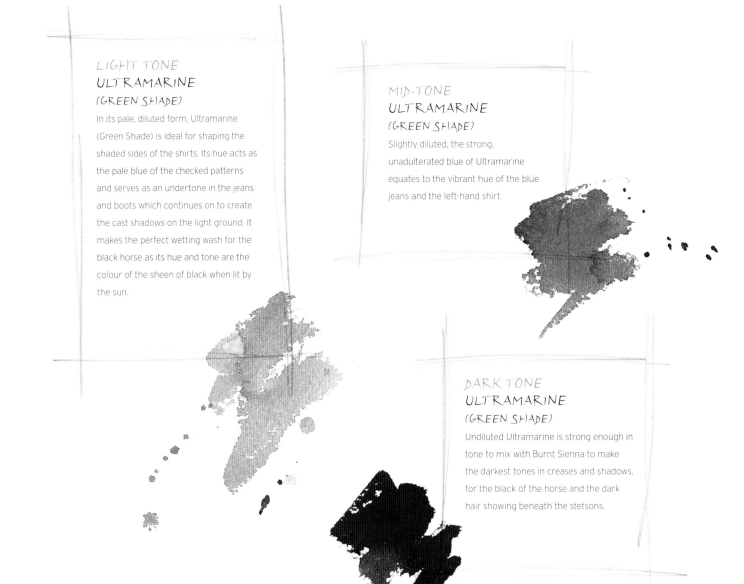

LIGHT TONE
ULTRAMARINE
(GREEN SHADE)

In its pale, diluted form, Ultramarine (Green Shade) is ideal for shaping the shaded sides of the shirts. Its hue acts as the pale blue of the checked patterns and serves as an undertone in the jeans and boots which continues on to create the cast shadows on the light ground. It makes the perfect wetting wash for the black horse as its hue and tone are the colour of the sheen of black when lit by the sun.

MID-TONE
ULTRAMARINE
(GREEN SHADE)

Slightly diluted, the strong, unadulterated blue of Ultramarine equates to the vibrant hue of the blue jeans and the left-hand shirt.

DARK TONE
ULTRAMARINE
(GREEN SHADE)

Undiluted Ultramarine is strong enough in tone to mix with Burnt Sienna to make the darkest tones in creases and shadows, for the black of the horse and the dark hair showing beneath the stetsons.

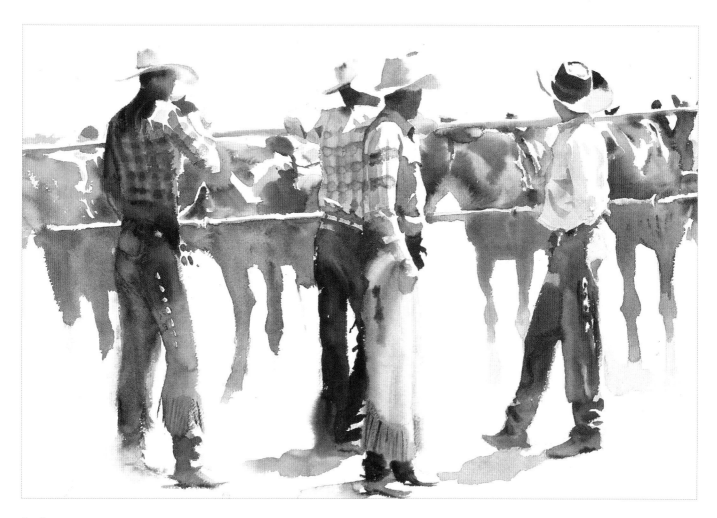

Cowboys

56 x 76cm (22 x 30in)

With just three colours – Ultramarine (Green Shade), Yellow Ochre and Burnt Sienna, laid both pure and mixed in many different tones – the cowboys are shown gathered together beside the rail of the corral. This warm, versatile blue represents both the shade on white and the light on dark, demonstrating perfectly that colour is relative to its surroundings.

A pale tint of Ultramarine represents the white shirt in shadow and the sheen of light on the black flank of the horse.

Ultramarine and Burnt Sienna meet in a wet-into-wet blend on the paper to create the shadow under the chaps.

Ultramarine and Burnt Sienna are mixed together in the palette with very little water to make the black for the cowboys' jeans.

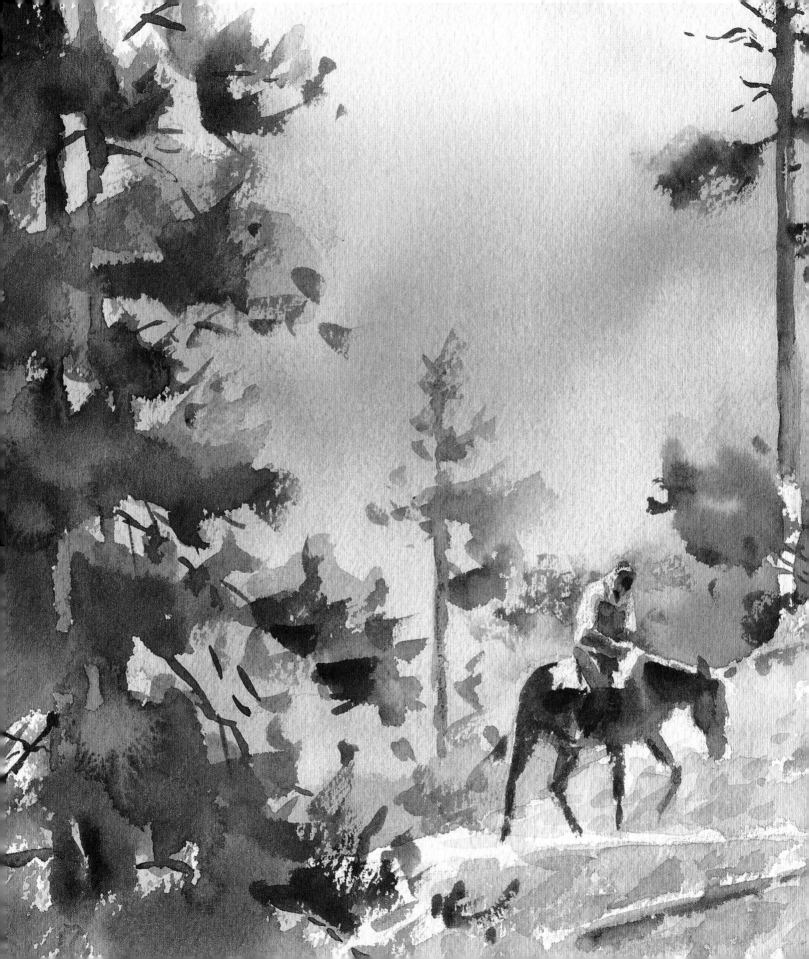

8. The Greens

While the secondary colours orange and violet have been included within the Yellow and Red chapters, the preponderance of green in landscape painting warrants this colour a chapter of its own. Ironically, while it is considered to be a psychologically calm, relaxing colour, the mixing of greens probably causes the most anxiety to the painter.

There are several ready-made greens but, as green is a secondary colour, it is very often mixed. Consequently, this chapter concentrates on the nature of the green required for a painting and discusses the two green pigments in my palette at the end.

Painting Bryce Canyon by Mule
23 x 20.5cm (9 x 8in)

Mixing Greens

AUREOLIN
AND
PRUSSIAN BLUE

FRENCH
ULTRAMARINE AND
INDIAN YELLOW

I nearly always mix my greens from blue and yellow, because the combination of the two colours creates a natural variation in a wash and assists the general harmony in the painting. The brightest and clearest greens are made by mixing a cool blue with a cool yellow, since both already veer towards green. Adding red to the mixture begins to tone the green down, since red is its opposite colour – so, by the same token, a warm blue and a warm yellow will make a quieter green.

Keep to the transparent colours to ensure vibrant greens, especially in layering, and mix with as few pigments as possible to maintain clarity. Mixing the opaque yellows and blues is often the cause of muddy watercolours, especially since the green areas of a painting often cover a large spread. Although most ready-made greens are made with more than one pigment, they can provide a more transparent or intense green than a mix made from a blue and a yellow.

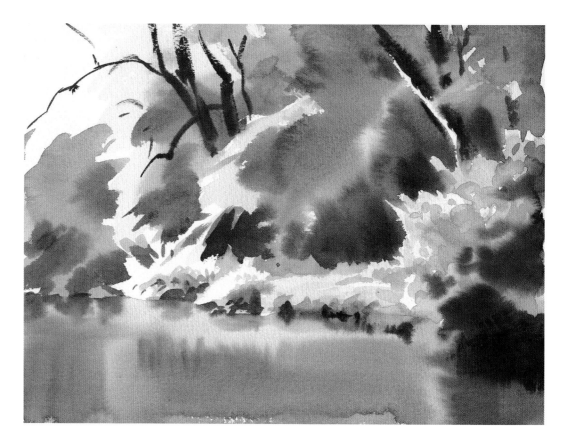

Hennerton Backwater
25.5 x 30.5cm (10 x 12in)
In this predominantly green painting, several mixed and ready-made greens are combined using Yellow Ochre, Aureolin, Prussian Blue, Ultramarine, Viridian and Burnt Umber.

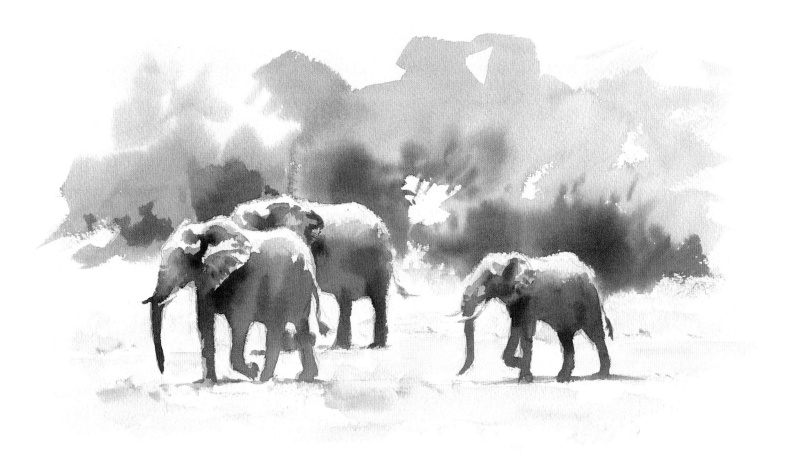

Tonal Value and Temperature

Since green is often laid in great swathes as foreground or background, its tonal value is key to the whole painting. Finding the tone of a green in your subject is consequently more important than matching its hue. Green is inherently a mid-tone colour, so it can be quite hard to assess the value of greens that are brightly lit or in shadow; the best way to check the tone is to look at the greens both in relation to the whole subject and against neighbouring tones, contrasting darker against lighter, lighter against darker.

Greens are cool colours that vary in temperature – the more blue the cooler the green, while with more yellow they veer towards warmth. Before you select the hues, think about what kind of green you are trying to achieve, since the clue to the temperature bias may be named in the words you use to describe it – for example, an acid green is a yellowy green, while a forest green is a bluer green.

Trio
25.5 x 30.5cm (10 x 12in)
In this sketch, Aureolin and Prussian Blue are mixed to make greens in a variety of tones: darker green brings out the light on the elephants' backs, while lighter green provides the counterchange to darker legs.

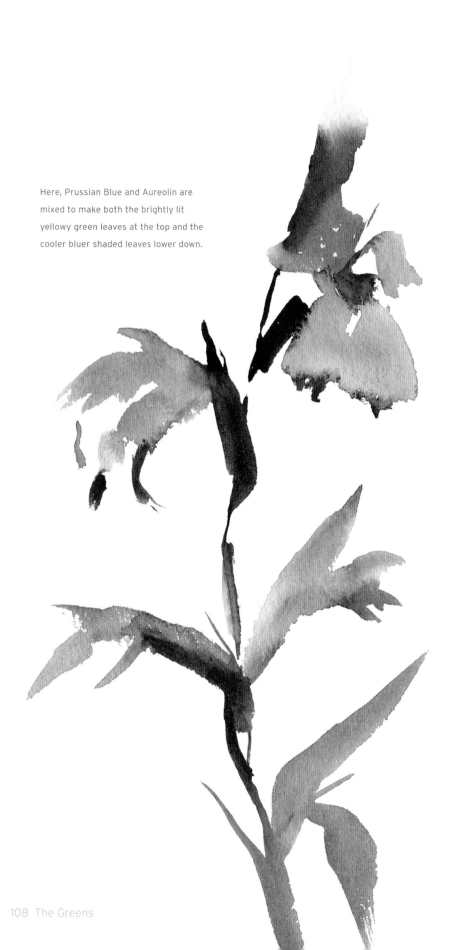

Here, Prussian Blue and Aureolin are mixed to make both the brightly lit yellowy green leaves at the top and the cooler bluer shaded leaves lower down.

Colours for Bright Greens

For bright greens you will need a cool blue and a cool yellow, such as Aureolin and Prussian Blue, with transparent pigments making the most radiant hues and allowing for layering. Lemon Yellow and Cerulean mix to a bright green, vivid in a single layer, but their opacity quickly sullies layering and mixes, as with Cadmium Yellow.

Since watercolour landscapes are often built up in layers from light to dark, it is best to save the opaque yellows for flat or fabricated greens, keep them to a single film and make the most of their covering power for restoring highlights in a foliage mass. Even with transparent greens you should try to lay the right tone with as few layers as possible.

LEMON YELLOW AND
CERULEAN BLUE

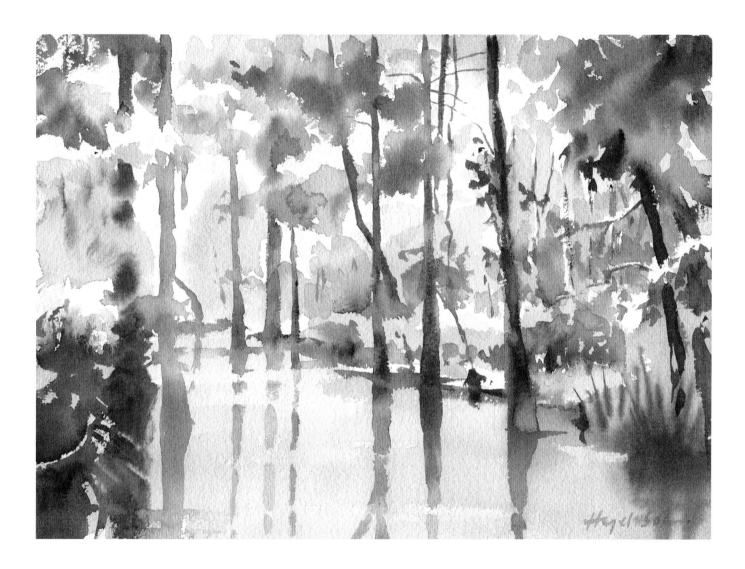

Alligator Alley

28 x 35.5cm (11 x 14in)

The cool tint of pale yellow in the water and behind the trees is the diluted Aureolin wash that was painted under the trees before Prussian Blue was added to the mix. The addition of Alizarin Crimson creates the darker shades.

Backlit Greens

Shimmering leaves backlit by the sun become very light in tone and bright in hue. Aureolin, a cool greeny transparent yellow, is the perfect colour for this. Dilute tints of any transparent yellow or green will suggest light coming through trees, or shining across grass, as soon as darker tones are placed around, on top or beside them. Brush these pale tints under all the areas where greens, browns and oranges are to be painted – as yellow belongs in all these colours it will serve as a unifying hue.

Natural Greens

Greens mixed from a cool blue and yellow may sometimes appear too garish for natural subjects such as foliage or grass. More natural greens can be mixed from blues and yellows of opposite temperature bias, one warm, one cool (for example Indian Yellow and Prussian Blue or Ultramarine and Aureolin). The subtlety is reached simply by the bias towards red in the warm pigments. Warm Cobalt Blue with cool Raw Sienna is a genial blend as it brings with it granulation and lifting possibilities. When both the blue and the yellow are warm, for example Ultramarine and Indian Yellow, the green becomes dulled, and therefore more subtle as the amount of redness in the mix increases.

There are several ready-made greens offering natural hues and clean transparency. A touch of a transparent red or red-brown mixed into a ready-made green will quickly temper the colour if it appears too bright. If the red is too close to an opposite, however, it will suck the life out of the green and make it dull.

YELLOW OCHRE UNDER ULTRAMARINE (GREEN SHADE)

YELLOW OCHRE WITH PRUSSIAN BLUE

YELLOW OCHRE WITH ULTRAMARINE

PRUSSIAN BLUE AND RAW UMBER

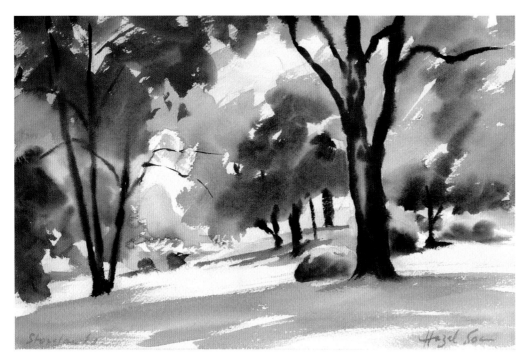

Sloping Summer, Stonelands
30.5 x 40.5cm (12 x 16in)
Here a wide variety of natural greens is reached by mixing cool and warm combinations: Prussian Blue with Indian Yellow and Aureolin with Ultramarine (Green Shade). The addition of violet creates lively dark greens and blacks.

Dull Greens

Watercolour is particularly beloved for the subtlety it can portray in painting dull greens which constitute a large part of landscape and flower painting, as they make attractive counterfoils for brighter hues. The low tinting strength of traditional colours such as Cobalt Blue and Ultramarine mixed with the yellows and browns of the earth colours make a range of attractive subdued greens which are enhanced by granulating properties. Far from looking dull in the other sense of the word, these subtle greens radiate mystery and magic.

In my palette it is Yellow Ochre that generally makes the dull greens. I mix it to a mid-tone on the palette with a cool transparent blue such as Prussian. In layering I often use Ultramarine (Green Shade) over Yellow Ochre tints but rarely vice versa – and I rarely mix them together as the colour can become muddy. Since greens become more subtle with the introduction of red, a three-colour palette is sufficient for a wide range of dull greens.

Guardians of the Cascade Mountains

20.5 x 28cm (8 x 11in)

In this three-colour painting, the dull, dark greens of the sentinel pines are mixed from Cobalt Blue, Raw Sienna and Burnt Umber. The darker mix of blue and brown does not even look green on the palette but works perfectly to represent the cool dark green of the closer pines.

Dark Greens

Possibly the hardest greens to mix are lively dark greens, especially if they need to cover a sizeable area. This is where the transparent browns come into their own. My favourite recipe is to engage a blue with an earth brown – Prussian and Burnt Sienna, for example, or Cobalt with Burnt Umber.

You can also mix transparent yellow and blue with a touch of red to make a dark green, but bear in mind that the most vibrant colours are mixed with the least number of pigments. The concentrations of Indian Yellow or Aureolin pigment required for a dark mixed green could become dangerously opaque and lose luminosity, in which case I substitute a ready-made green.

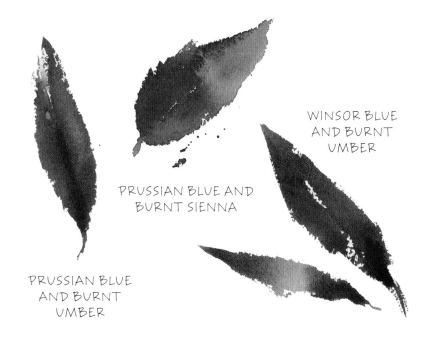

WINSOR BLUE AND BURNT UMBER

PRUSSIAN BLUE AND BURNT SIENNA

PRUSSIAN BLUE AND BURNT UMBER

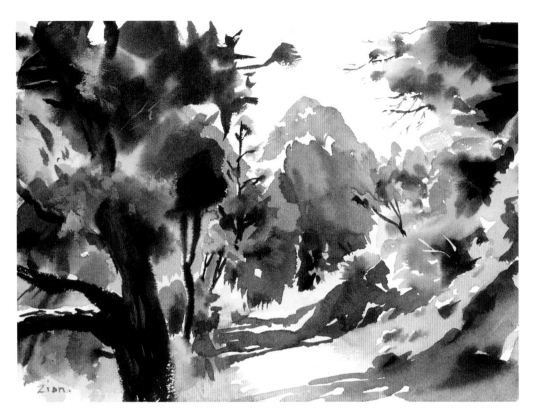

The vibrant dark green foliage on the pine trees is reached by mixing the transparent Permanent Sap Green used for the lighter foliage with the transparent Brown Madder used for the red earth, the opposite colours making a vibrant dark green.

Ready-made Greens

Green Gold, Permanent Sap Green, Olive Green, Viridian, Hooker's Green and Perylene Green are all glorious transparent greens ranging from yellow to blue shades. The clarity of transparent ready-made greens can be ideal for making dark greens with opposite brown and red pigments. Choose a transparent combination that works for the lighter tones and hues as well as the darks so that harmony is maintained throughout the painting.

Since you cannot carry every colour with you and it is of no benefit to include too many colours in a painting, the useful colours are the ones that are multipurpose. I keep just two ready-made greens in my palette, Viridian for the bluer greens and Permanent Sap Green for the yellows, and use them mainly for specific local colours.

Permanent Sap Green (T) warm

Originally made from unripe berries, Permanent Sap Green is one of the early modern carbon colours. It is a bright, leafy green, transparent and staining and, being high in tinting strength, it provides a speedy result. As it is dark in its concentrated form you can guess that it will mix well with opposite colours to make dark greens.

GREEN
GOLD

OLIVE
GREEN

HOOKER'S
GREEN

PERYLENE
GREEN

Viridian (T) cool

Made from chromium oxide, Viridian entered the artist's palette in 1838. It is an exotic green that has no substitute. Viridian is both transparent and granulating and its blue undertone makes it ideal for emerald greens and cool green foliage. I turn to it often for architectural features, such as painted shutters and gates – it seems to suit the dark green paint much used on buildings. It is also ideal for mixing the turquoises of water, especially the deep transparent green seen under rising ocean waves (see page 101). Viridian is one of the few colours that can make a single appearance in a painting without jarring or robbing it of harmony as it seems to work well in isolation.

Highway through Lesotho
20.5 x 28cm (8 x 11in)
In this pastoral encounter on a road through Lesotho I have blended the opposite colours Viridian and Alizarin Crimson to make a pleasing greyish-green background. The same two colours mix to make the black legs of the sheep and the purple of the shepherd's blanket.

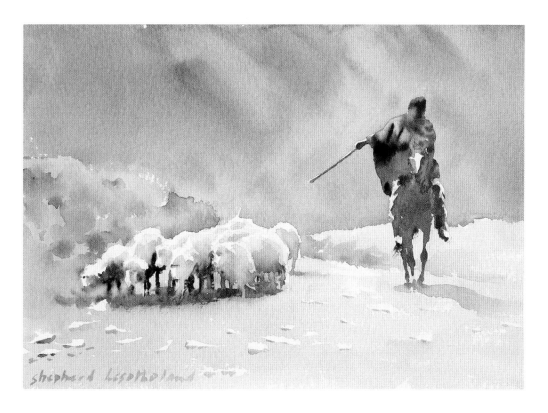

Playing with Green

The variety of greens in the natural world may call for a range of blues, yellows and ready-made greens. Harmony is crucial, so you need to pull the painting together by seeing the greens in terms of their temperature in relation to their close and more distant neighbours. That way the greens will interlink across the painting and enhance each other rather than separate into disparate elements.

PRUSSIAN BLUE AND INDIAN YELLOW

The duller greens are represented by a combination of the cool transparent Prussian Blue and the warm transparent Indian Yellow. This warm yellow therefore becomes the choice to mix the orange for the roses, completed by Permanent Rose. This cool pinkish-red would be a killer in dark green mixes, so Winsor Violet is added because it blends well with Permanent Sap green to make deep translucent darks.

PRUSSIAN BLUE AND AUREOLIN

The cool blue and cool yellow mix offers the option of a variety of bright yellowy greens. The Prussian Blue sends the leaves into shadow and cools down the greens, while the Aureolin brings clear yellow to lift and lighten the acidity of Permanent Sap Green.

PERMANENT SAP GREEN

This colour offers a caustic transparent green as a link throughout the painting; the blue and yellows can be mixed with it to turn the temperature cooler or warmer and so present the wide variety of greens that are present. The high transparency allows for deep transparent darks when it is mixed with Winsor Violet.

COBALT BLUE

The shadows on the white flowers and behind the lit side of the bunch look too warm for Prussian Blue, so Cobalt Blue is introduced on the right-hand side of the painting. Its clear blue hue opposes the orange of the roses, enhancing their brightness by contrast, and its semi-transparency steps it gently back behind the flowers yet maintains the hue.

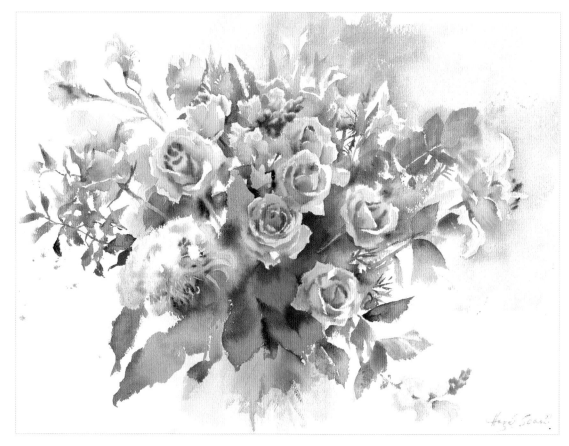

Gift from Friends
56 x 76cm (22 x 30in)
Permanent Sap Green runs
through most of the greens
to bring colour cohesion to
a painting with many
disparate elements. Wet-
into-wet blends further aid
the melding of the whole
composition.

Neat Permanent Sap Green is touched into the
dilute tint that shapes the collection of buds. The
darker tone indicates the small rounded forms of
the nascent flowers.

Along the plane of a single leaf, any twist will catch
the light in different measure, turning greens
warmer or cooler within a single brushmark. This
variety keeps the painting alive.

Winsor Violet is touched into Permanent Sap
Green behind the petals to make a colourful
transparent dark. The blue in the Violet also helps
the peachy orange of the roses to appear brighter.

9. The Browns

Brown is a warm tertiary colour mixed from all three primaries. Its hue is therefore very versatile, depending on which primary is in the ascendance, and its tone can range from the palest stain to almost black. The ready-made browns are also vital to the artist's palette.

Since browns occur frequently and are often the darkest tone, their lively appearance is crucial to the success of a painting. Well-chosen brown washes can be dazzling, with splendid depths of colour, while badly mixed browns may turn a vibrant watercolour into a dull and dirty image. Small areas are not problematic; it is when large areas of potent darkness are needed that hesistation steps in - deep brown washes are sometimes avoided rather than tackled, hence the reason why watercolour is often regarded as a weak and pale medium and a poor relation to oils. Learn to paint vibrant darks and watercolour has no match.

Yassen Sleeping
30.5 x 30.5cm (12 x 12in)

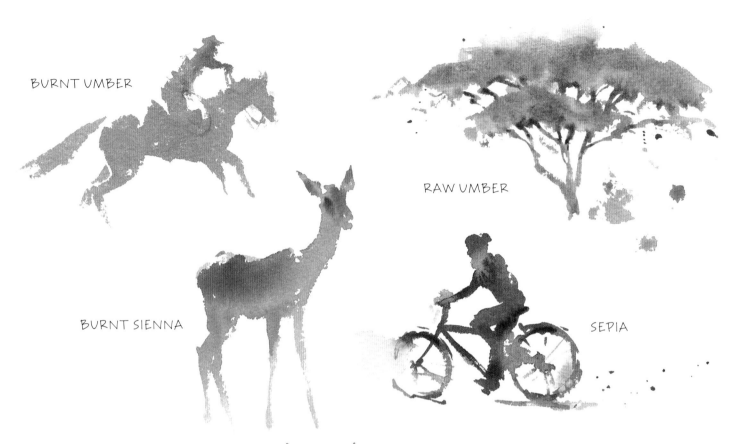

BURNT UMBER

RAW UMBER

BURNT SIENNA

SEPIA

Mixing and Choosing Browns

BROWN MADDER

Red, yellow and blue mix to make browns, so it follows that a variety of browns can also be mixed from two opposite colours by juggling the mix and favouring a dominant hue. Indian Yellow and Winsor Violet make a warm brown, Cadmium Red and Ultramarine a quiet recessive brown, the opaques make misty browns and Alizarin and Permanent Sap Green produce an arresting foliage brown – combinations are limitless.

The excellent ready-made browns available in watercolour speed up the process of yielding deep colours and achieve a brown from fewer pigments, creating tints and washes of great clarity and transparency. The aim is to make browns delicious, even if they are not the colour of chocolate!

Undoubtedly it is large dark washes that are the hardest thing to manage in watercolour, and mixing enough paint from the outset is crucial. A dark transparent colour can appear less transparent than a light colour, so painting in a single layer gives it the maximum clarity by allowing more light to filter back to the viewer between the particles as well as through them. Another layer would effectively fill in those gaps, compromising transparency.

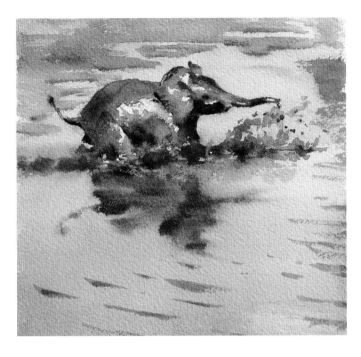

Fine-tuning a Brown

The hues and tones of browns are adjusted with the addition of another colour. The choice is directed by temperature bias and translucence. Choose a ready-made brown that approximates to the predominant hue of the subject, then enhance the temperature by adding a warmer hue, or temper it with an opposite colour. Consider whether it is a reddy, yellowy, greeny or bluey brown, warm or cool, how dark it is in relation to the colours around it and the whole picture.

For example, to make Burnt Sienna warmer you might add Cadmium Red, or to cool it down add Prussian Blue. If you needed a deeper brown you could introduce Winsor Violet. The result is a wide variation of browns unified by a single brown pigment.

Muddy Child
20.5 x 28cm (8 x 11in)
Browns can be readily mixed from red, yellow and blue. Here, the cool dark brown of the muddy elephant is made with a mix of Prussian Blue, Alizarin Crimson and Yellow Ochre.

Race to the Finish
40.5 x 51cm (16 x 20in)
In this painting, Burnt Sienna is chosen as the basic chestnut brown for the horses' hides and is turned cooler by adding Ultramarine, warmer with Permanent Rose and Cadmium Red, and darker with Winsor Violet, thus making at least six different browns. All the colours are also included in the jockeys' silks to maintain harmony.

Mingling with Opposites

In general, brown is a warm tertiary hue – blacks and greys are the cool tertiaries. Warm browns veer to the yellow/red side of the spectrum and mix with opposite blues to make cooler, darker browns. Mixing browns with opposite colours neutralizes both colours, whereas blending the pure colours on the paper preserves the individual hues, as you can see in this selection of watercolours.

Raw Umber and Prussian Blue would mix to green in the palette, but here they blend on the paper to make an attractive counterchange of warm and cool hues on the meerkats.

Burnt Sienna finds a perfect opposite in Ultramarine (Green Shade). They would result in a neutral grey if mixed, but intermingling the two colours wet-into-wet on paper keeps both hues intact and radiant blends arise, as shown below.

Lesotho. Hazel Soan.

Lesotho Journey
20.5 x 28cm (8 x 11in)
Here, the red in Brown Madder and the blue of Ultramarine
(Green Shade) blend together to make dusky violets.

Burnt Sienna (T) warm

Among the most useful colours in the palette is Burnt Sienna, which has been around for a long time; it is one of the original earth colours, made by roasting Raw Sienna to make it redder. Now it is often made from synthetic iron oxide and even more transparent. It dilutes to a lovely floating orange hue akin to the colour of warm flesh or red soil. It is so clear and transparent that it is perfect for mixing dark colours; in its concentrated form straight from the tube it can be mixed with Ultramarine to make a black and diluted to make gentle neutral greys that can be geared towards cool or warm shades with ease.

Burnt Sienna blends easily with other colours, so you can quickly dull a green or darken an orange with just a dash. I would be lost without it in the animal kingdom and often use it as the 'red' in an African three-colour palette. It dries very hard in the palette and takes time to work up to a deep tone, so I recommend you also carry a tube for instant fluidity.

The predominant brown of the impala is a warm orangey hue, so Burnt Sienna is perfect as the base brown while Yellow Ochre lightens and brightens it and Ultramarine cools and darkens it to reach the blacks.

Cavalier Colours
30.5 x 40.5cm (12 x 16in)
The warm transparent brown of Burnt Sienna captures perfectly the sheen of the chestnut pony, while a tinge of Ultramarine (Green Shade) added to the same brown gives the competitor's horse a cooler but equally rich brown hue.

Venetian Reds
28 x 20.5cm (11 x 8in)
The hot transparent glow of Brown Madder befits the radiant reddy brown walls along this shaded Venetian canal. Cool, transparent Winsor Violet is added to mix the darks.

Brown Madder
(T) warm

This colour is derived from carbon though its original pigment was from the madder root. Extremely transparent and redder and warmer than Burnt Sienna, it has become essential to me in Kenya and Tanzania for the hues of deep red soil and the exquisite rich browns of African skin. It is also an ideal hue for the red pantile roofs of the Mediterranean, classic red sails, and the coloured walls of Venice.

Burnt Umber (T) warm

Formed by heating Raw Umber, Burnt Umber is a dark yellowy-brown earth colour. The name probably comes from the Latin for shadow, *umbra*. It is a pleasing, natural-looking brown, nicely transparent, and a great base colour for mixing vibrant darks, especially in foliage. Though it is not a staining colour, particles of pigment nestle in the hollows of paper and leave their trace when lifted off. It dilutes to a dark golden yellow but can deaden in dense form, so I often mix it with the transparency of Winsor Violet or with Ultramarine for deeper darks. It is happier than most colours to be pushed around and can make attractive leathery effects when washed off and re-tinted.

Raw Umber (T) cool

A natural iron oxide, Raw Umber is a cool, transparent mid-brown earth pigment with attractive granulating properties. Its granulation creates valuable textures in broad washes, but this natural tendency to separate means it does not spread easily or uniformly so I rarely add it into wet-into-wet washes, preferring to mix it in the palette with colours such as Winsor Violet or Ultramarine, which help it to flow more reliably. Its low tinting strength blends well for natural greens.

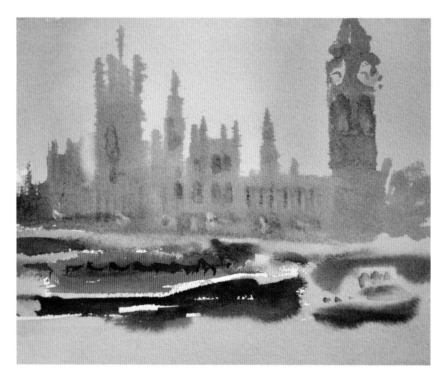

The Queen's Barge, Diamond Jubilee
18 x 15cm (7 x 6in)
A wash of granulating Raw Umber describes the historic shape of the Houses of Parliament. The cool-mid-brown stays back while the red of the barge thrusts forward, providing instant space in a small sketch.

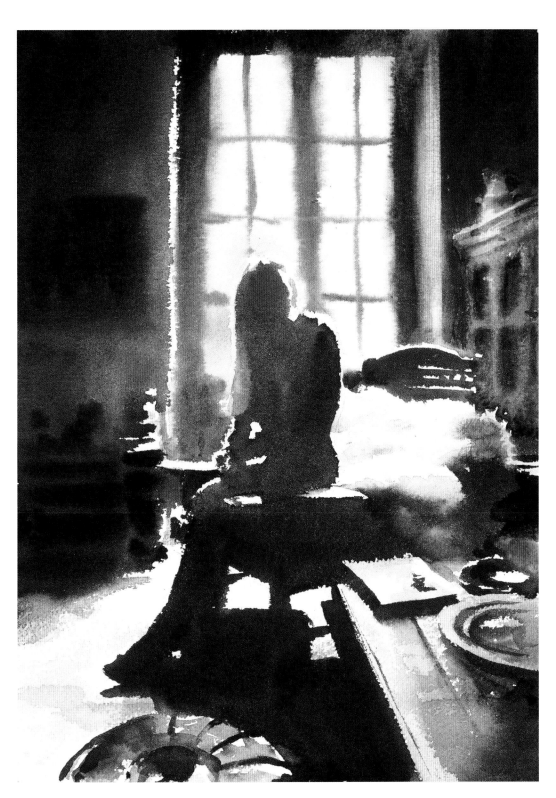

Mary, Notting Hill
40.5 x 30.5cm (16 x 12in)
A variety of warm and cool browns inhabit this interior. Burnt Umber is mixed with Ultramarine (Green Shade) and touches of other transparent and opaque tints guide the hues. The darkest tones are brushed into the lighter washes wet-into-wet to ensure the maximum translucency offered by a single film of paint.

Sepia (O) Warm

This is a very dark brown, originally made from the ink of the cuttlefish but now produced from carbon black and synthetic iron oxide. It is the darkest of the browns and varies in opacity. Classed as a warm brown, it looks cold or warm depending on what lies adjacent. It can deliver an immediate dark, but keep it to single layers or you will kill off transparency. Being dense in concentrated form, it moves slowly outward in wet-into-wet washes so is easy to manage for details such as the specific markings in wildlife. As you will see on pages 132 and 133, it mixes with Indigo to make a delicious black.

The inherent darkness of sepia can be seen in the nostrils and eyes of this giraffe. Against the warmer Burnt Sienna of the horns, the Sepia is a bluer brown and therefore appears cool.

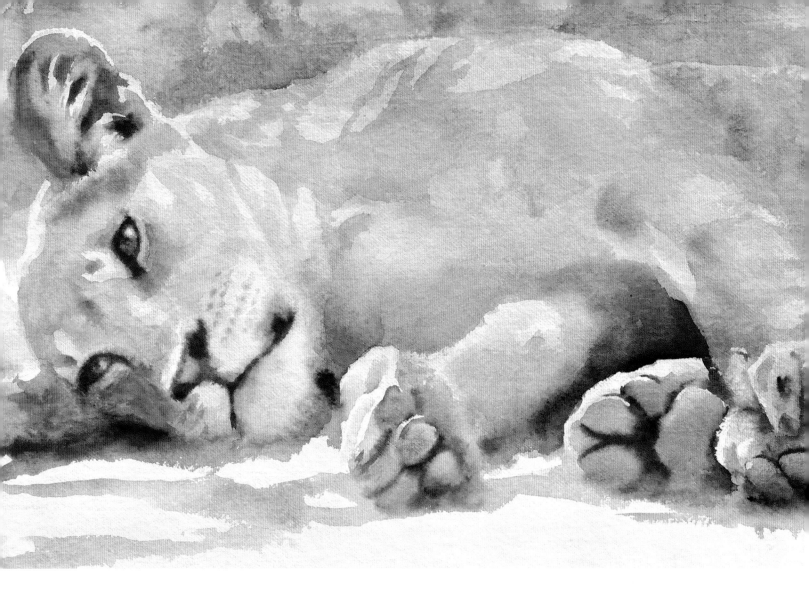

Tender But Tough
56 x 76cm (22 x 30in)
The dark markings around the eyes, nose and mouth of this lioness look natural because they are softened at the edges by painting the neat Sepia into paper dampened first with clean water.

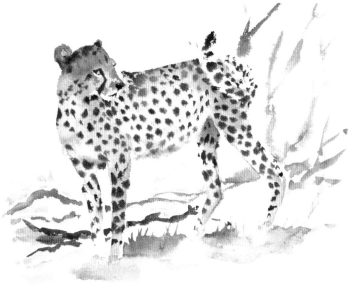

The numerous spots on the cheetah's pelt are painted with concentrated Sepia dotted into a damp wash. The dense pigment barely spreads, so the marks remain round and soft.

Playing with Browns

Brown is by nature versatile because it includes all the primary hues. Most of the browns I use are earth colours. The intrinsic harmony of the earth colours allows a great deal of fun to be found by building a painting from light to dark, using the gradual deepening of the tones of each pigment.

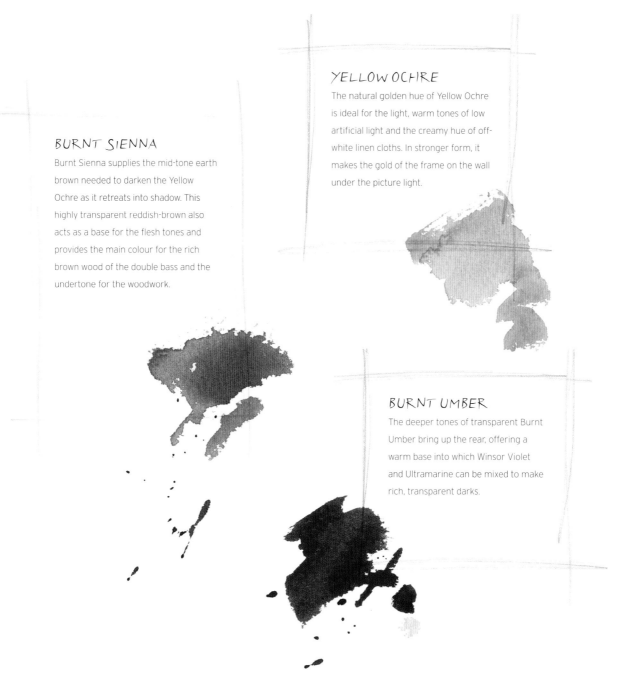

YELLOW OCHRE

The natural golden hue of Yellow Ochre is ideal for the light, warm tones of low artificial light and the creamy hue of off-white linen cloths. In stronger form, it makes the gold of the frame on the wall under the picture light.

BURNT SIENNA

Burnt Sienna supplies the mid-tone earth brown needed to darken the Yellow Ochre as it retreats into shadow. This highly transparent reddish-brown also acts as a base for the flesh tones and provides the main colour for the rich brown wood of the double bass and the undertone for the woodwork.

BURNT UMBER

The deeper tones of transparent Burnt Umber bring up the rear, offering a warm base into which Winsor Violet and Ultramarine can be mixed to make rich, transparent darks.

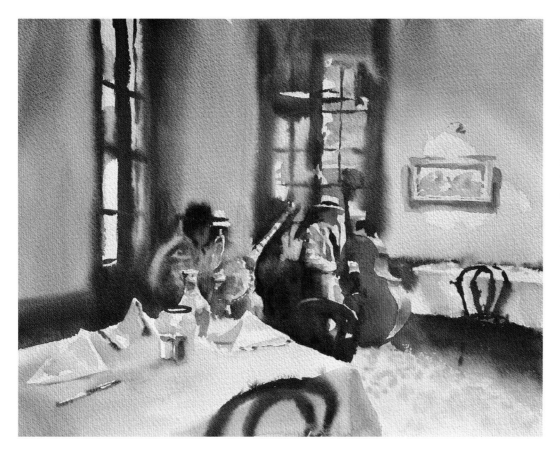

30.5 x 40.5cm (12 x 16in)

The dim light pervading the musicians' haunt is built up with the natural tonal ascendancy of three different earth colours: Yellow Ochre, Burnt Sienna and Burnt Umber. Cadmium Red, Winsor Violet and Ultramarine (Green Shade) are introduced to tweak the browns up or down in temperature and strengthen tone or body.

Cadmium Red is blended with the Burnt Sienna to make a hotter brown for the face and double bass, while Winsor Violet deepens the browns against the walls but keeps them warm. Ultramarine darkens and cools the brown for the tie and hatband and the shadow at the back of the jacket.

The hues of the yellow, red and blue used in the painting are encapsulated in the still life on the table. Pure tints of Yellow Ochre, Cadmium Red and Ultramarine (Green Shade) create a light key to counterbalance the dark tones beyond.

The dark brown of the chair back is applied before the tablecloth wash has quite dried to create a more lively appearance and then blends with the shadow under the table to add a touch of ambiguity.

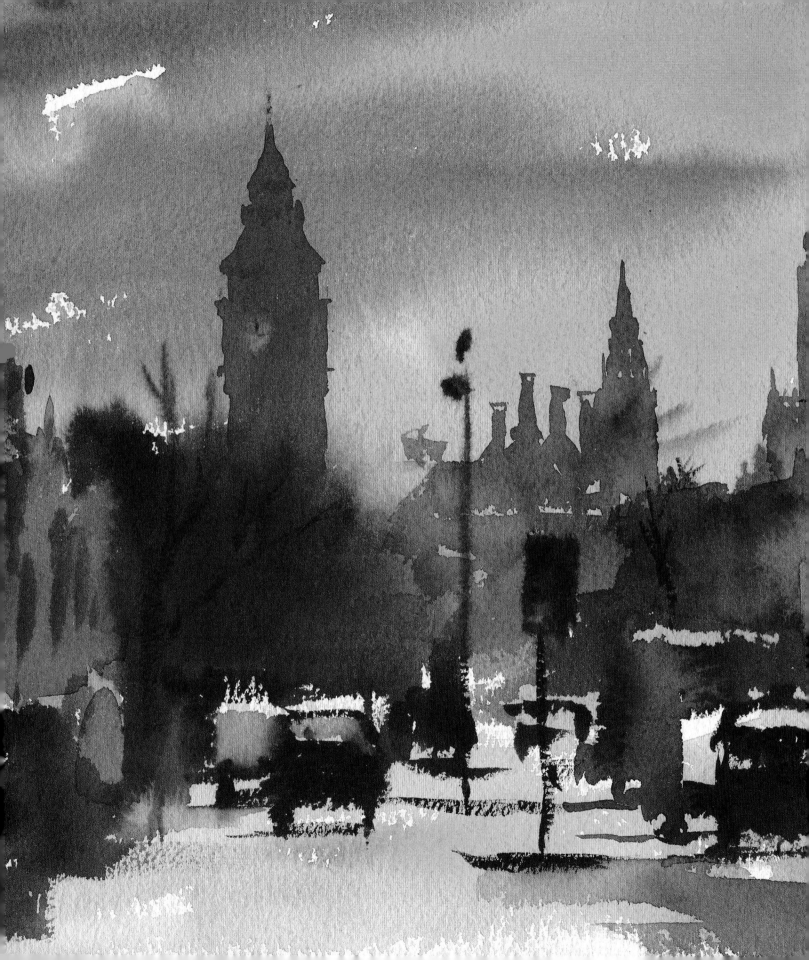

10. The Blacks and Greys

Black, the sum of all colours, is rarely used as a ready-made colour in watercolour because so many delicious blacks can be mixed from primary and opposite hues. In painting, the darkest tone is always relative to the other tones, so a black can be implied even if it is not yet black. By default, black is opaque because it absorbs all light and reflects none back, but blacks mixed from three transparent colours can have an alluring depth without looking flat, especially if painted in a single flowing film of paint.

Greys are the cool tertiary colours, the lighter shades of black. Watercolour is known for its ability to make luminous, subtle greys, full of atmosphere and colour. There are a number of ready-made greys and blacks but I rarely use them in my palette, so this chapter is about mixing blacks and greys.

Drifting Down Whitehall
30.5 x 25.5cm (12 x 10in)

Mixing Blacks

INDIGO MIXED WITH SEPIA

In theory, yellow, red and blue make black, but in practice a true black can only be made from mixing transparent primaries. You need to look to three transparent colours similar to those of process printing – cyan, magenta and yellow. One combination would be Winsor Blue, Permanent Rose and Transparent Yellow, but any red, yellow and blue transparent combination can reach black if the hues are balanced correctly, which is to say a red leaning to blue, a blue leaning to green and a primary yellow. Indanthrene Blue, Quinacridone Red and Quinacridone Gold are also a trio that make a fine black.

Plan the black at the start of the painting so that it harmonizes with the whole. If a colour is dark in the palette you can use it to create black, but if it is not it will lighten, modify or muddy black. To mix blacks from two colours, pick a dark, transparent cold blue or green and add its dark transparent opposite brown or red, for example Viridian and Alizarin Crimson, Burnt Sienna and Ultramarine (Green Shade), French Ultramarine and Burnt Umber, or Indigo and Sepia. A delicious black is made from Cadmium Red and Prussian Blue, despite the red being opaque, because they are extreme opposite colours.

The secret with dark colours is to apply them bravely and boldly. Remember that in the mixing of pigments the tendency of adding successive colours is always towards black, so you need to take control of the mix to reach the black of your choice.

In the Clearing
25.5 x 30.5cm (10 x 12in)
The black stripes of the zebra are mixed from Ultramarine (Green Shade) and Burnt Sienna, two colours already used in the painting, so that the blacks harmonize rather than jumping out to the eye.

OK Corral, Tombstone, Arizona
56 x 76cm (22 x 30in)
The velvety blacks of the coats worn by Doc Holliday and the Brothers Earp
are painted with Indigo and Sepia mixed together straight from the tube. To be
sufficiently dark the mixture cannot be too runny, so each figure is presoaked
with dilute Indigo and the black mix is then brushed into the damp wash. The
colour spreads and blends, and thus avoids seams.

BURNT SIENNA AND FRENCH ULTRAMARINE

ALIZARIN CRIMSON AND VIRIDIAN

Mixing Greys

In its more dilute form, any mix for black will present a grey, and although the combination of the closest colours to the three primaries, Cadmium Red, Cadmium Yellow and Cobalt Blue, cannot reach black because of their opacity, they do make lovely opaque greys.

Like all hues, greys are classed by temperature bias, so a cool grey veers towards blue or green and a warm grey leans to yellow or violet. When they are mixed from just two colours it is easy to adjust the temperature because each of the colours used will represent a bias. If Ultramarine and Burnt Sienna are mixed, for example, more blue added will make the grey cooler, while more Burnt Sienna will make it warmer.

Compensating Colours

To boost an adjacent hue, offset it with a grey of opposite bias. By dint of compensation the eye will already see the grey as leaning to the colour missing from the circle, so all you need do is enhance the effect. For example, if you increase the blue bias in grey shadows behind some yellow flowers, the yellow will look more vibrant.

The ready-made greys Paynes Grey, Neutral Tint and Davy's Grey are lovely greys of differing bias, but I barely use them. I prefer the colourful greys made from mixing, and the unity and confines imposed by a limited palette.

Please note that adding grey is not the way to darken a colour or to put in shadows – that way lies the path to dullness.

Jubilee Guards
18 x 12.5cm (7x 5in)
Ultramarine (Green Shade) and Raw Umber make a lovely smoky grey for the river which fills the background behind the saluting officers at the Queen's Diamond Jubilee River Pageant.

the city from the Embankment

Unlimited Shades of Grey
20.5 x 20.5cm (8 x 8in)
With a limited palette of three colours, a variety of greys can be reached. The greys bathing the city of London are mixed here with different blends of Aureolin, Prussian Blue and Alizarin Crimson.

Playing with Greys

You can mix greys in your palette or blend them on paper from any combination that includes the three primaries, so once again it is the type of grey – cool or warm, transparent or opaque, granulating or lifting – which will guide the choice of colours. Unless you know exactly what is on your palette, do not be fooled into mixing grey from whatever is left lying there – you may end up with a lifeless grey and introduce mud into your painting.

Vibrant Trios

The four elephants here are all painted in a similar fashion but with different colour combinations of yellow, red and blue applied wet-into-wet in the order of their inherent tonal values. The transparent colours remain clear and vibrant as they get darker and deeper, while the opaque hues add their punch and settle undisturbed.

YELLOW

The light-toned yellow is painted in a pale wash to create the shape. No drawing is necessary because the yellow is so pale it can be easily corrected without any error being visible.

Quinacridone Gold (T), Quinacridone Red (T) Indanthrene Blue (T)
Three strident transparent primaries guarantee a black for the shadow details. Bright, vibrant greys can be veered to brown, purple or blue depending on the amount of pigment in each blended wash.

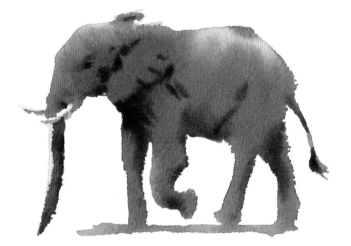

RED

While the wash is still wet the mid-toned red is added in a slightly drier solution. It is touched in from the shaded side of the limbs, head and torso and allowed to spread across the mid-toned and dark-toned areas of the bulk of the elephant.

Yellow Ochre (SO), Alizarin Crimson (T) and Prussian Blue (T)
A soft, pleasing grey is made from blending one semi-opaque with two transparent colours. Using Prussian as the blue ensures a cool cast.

BLUE

The blue, the darkest-toned primary by nature, is added wet-into-wet in an even less wet mixture as there is now water on the paper from both the previous layers. To enhance form, the pigment should be added from the point of darkest tone or deepest hue. So long as the wash is wet you can keep adding more pigment to intensify, or modify, the hue and tone.

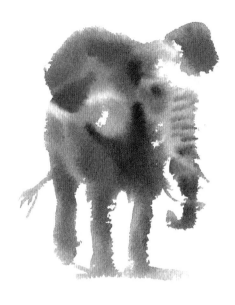

Aureolin (T), Winsor Violet (T) and Ultramarine (Green Shade) (T)
In these three transparent colours the mid-tone is Ultramarine because the Violet is darker in tone, so the order is changed: Aureolin is the first pale wash, Ultramarine second and then Winsor Violet. Lastly the three colours are mixed together for the darks.

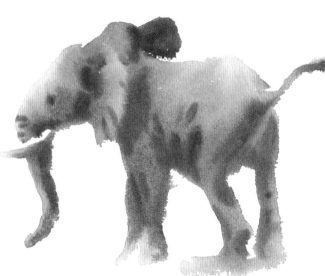

THE MIX OF THE THREE PRIMARIES

The dark details that describe the eye and hint at creases and wrinkles, along with the shadows behind the ear and under the head and tummy, are a very dry mixture of all three colours touched in while the paint is still damp. Obviously, the drier the added colour, the less it will spread.

Cadmium Yellow (O), Cadmium Red (O), and Cerulean Blue (O)
Three opaque colours blend to a quiet, gentle grey. Notice how light the three-colour mix for the details and creases is compared to the black of the three transparent pigments.

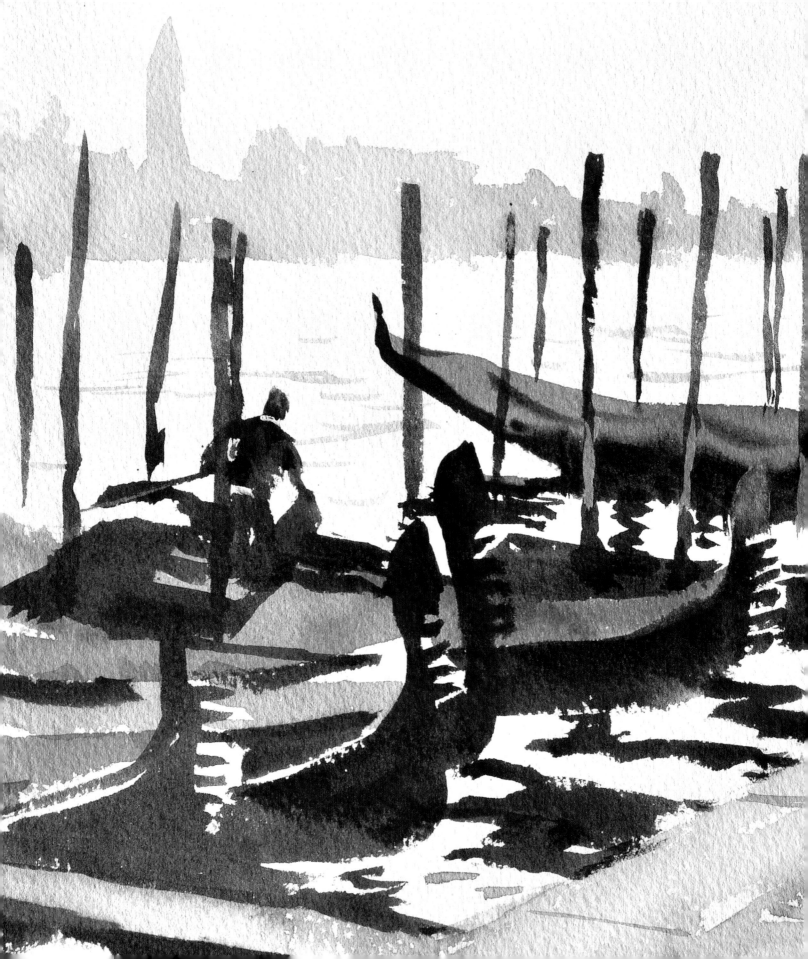

11. The Whites

The white of the paper provides the brightest whites in watercolour. In fact, since every glaze requires a light ground to show off its luminosity, the white paper on which watercolour is painted is as important as the colours themselves.

White paint is available in watercolour, but while it is used to restore small areas of light, it cannot restore the original brightness of the paper. Even though the traditional papers are a creamy off-white, white paint still looks darker than the paper because of its opacity.

Waking Up on the Grand Canal
25.5 x 28cm (10 x 11in)

The White Paper

The paper used for watercolour varies in fabrication, whiteness, texture and weight. Because watercolour is a transparent medium, the background colour matters, but as each painting is made up of colours relative to each other and the background, the lightness of the white is not crucial. I find that cool subjects with blues, whites and violets can look fresher on a high white paper, while warmer subjects with oranges, reds and yellows suit the traditional creamy white. Papers made from 100 per cent cotton are more manageable for wet-into-wet blending; the heavier the weight and rougher the surface, the more water they hold, prolonging the drying time.

White paper provides the reflective surface to make watercolours glow, so it should be handled with respect. Place nothing on it other than brushstrokes. Avoid touching the paper – even paint-free fingers plant grease marks – and keep it covered. It needs to be pristine to deliver luminosity.

Restoring White Highlights

Reserving patches of untouched white paper in a painting is a major part of watercolour technique, but small highlights can also be restored with opaque white. These will appear as untouched paper if they are surrounded by much darker tones. The ability to add highlights later enables you to paint broad, dark washes freely rather than fiddle the brush around myriad small shapes. There are two whites in most watercolour ranges, Titanium and Chinese, but since white is generally used for its opacity, some watercolourists also use white gouache.

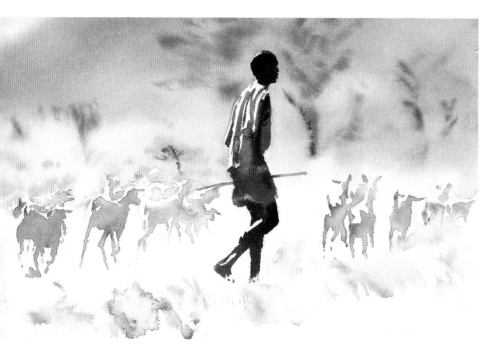

Life Alongside Fisherman's Wharf, San Francisco (right)
23 x 30.5cm (9 x 12in)
In this painting, dry Titanium White has restored the highlights not already protected by masking fluid, but so effective is the addition that it would be hard for the viewer to tell the difference in technique.

Belonging to the Flock (left)
51 x 35.5cm (20 x 14in)
The white paper is the palest tone in a painting and therefore represents light. The bright dazzle of the African plain is lucidly expressed in this painting by leaving the paper in the foreground completely untouched.

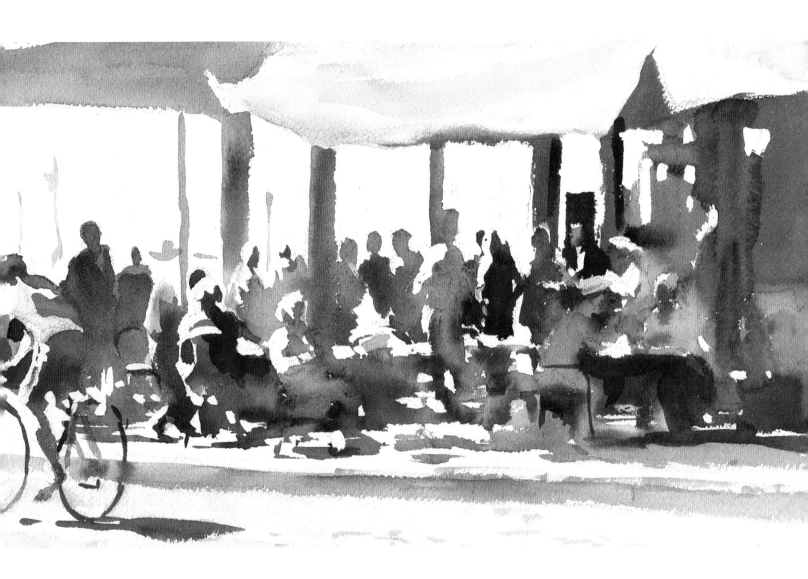

Titanium White (O) warm

This white is very opaque and has splendid covering power. It is ideal for restoring highlights and making corrections. Restrict it to smallish areas as it can become shiny when applied thickly. It looks lighter and whiter when wet, so you may need to make several applications to reach a bright white. Opaque white should only be added when there is no chance that any more glazes will be laid, otherwise it will lift off easily and grey down any subsequent wash.

Chinese White (SO) cool

Made from zinc, Chinese White is a bluish semi-opaque white. It has low tinting strength so it is ideal for muting and knocking back garish colours and can be used as a wash to 'mist' over areas. It is not as opaque as Titanium White so cannot restore highlights as effectively.

The End
of the
Rainbow

Well, we have reached the end of the rainbow, but this is only the beginning: the treasure box has been opened for you to delve inside.

I hope I have whetted your appetite to continue the adventure and made you more familiar with the extraordinary potential offered by the colours in your palette. Like me, you will probably fall in love with their personalities and want to give them the freedom to shine on the paper in their own inimitable fashion. The watercolour medium is perfect – trust the colours to deliver and be kind to the particles, since happy pigment makes vibrant paintings!

Large Glass
76 x 101.5cm (30 x 40in)

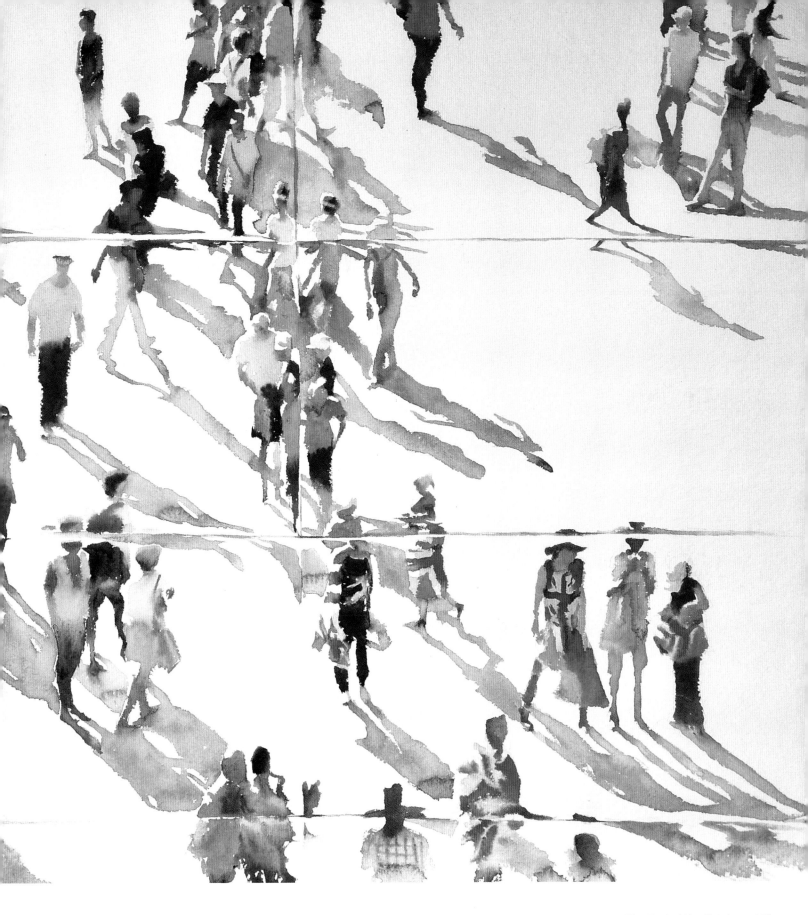

Further Reading

Doerner, Max. *The Materials of the Artist and Their Use in Painting* (Harcourt Brace, 1984)

Finlay, Victoria. *Colour: Travels Through the Paintbox* (Sceptre, 2003)

Jennings, Simon. *Collins Artist's Colour Manual* (Collins, 2006)

Soan, Hazel. *The Essence of Watercolour* (Batsford, 2011)

Index